EDIBLE PLANTS

JIMMY W. FIKE

EDIBLE PLANTS

A PHOTOGRAPHIC SURVEY OF THE WILD EDIBLE BOTANICALS OF NORTH AMERICA

RED ⚡ LIGHTNING BOOKS

This book is a publication of

RED ⚡ LIGHTNING BOOKS

1320 East 10th Street
Bloomington, Indiana 47405 USA

redlightningbooks.com

© 2021 by Jimmy Fike

All rights reserved
No part of this book may be reproduced or utilized in any form or by any means, electronic or mechanical, including photocopying and recording, or by any information storage and retrieval system, without permission in writing from the publisher.

This book is printed on acid-free paper.

Manufactured in Korea

Second printing 2022

Library of Congress Cataloging-in-Publication Data

Names: Fike, Jimmy W., author, photographer.
Title: Edible plants : a photographic survey of the wild edible botanicals of North America / Jimmy W. Fike.
Description: Bloomington, Indiana : Red Lightning Books, 2022.
Identifiers: LCCN 2021027619 (print) | LCCN 2021027620 (ebook) | ISBN 9781684351718 (hardback) | ISBN 9781684351701 (ebook)
Subjects: LCSH: Plants, Edible—North America—Identification. | Plants, Edible—North America—Pictorial works.
Classification: LCC QK98.5.A1 F55 2022 (print) | LCC QK98.5.A1 (ebook) | DDC 581.6/32097—dc23
LC record available at https://lccn.loc.gov/2021027619
LC ebook record available at https://lccn.loc.gov/2021027620

This book is solely intended for educational and artistic purposes. Neither the author nor publisher assume liability for ingesting or utilizing plants listed in the book. It is recommended that other primary sources are consulted to provide positive, authoritative identification and that soil and water quality are assessed before eating any wild edible plants.

To my precious daughter,
Isobel Lee; one of my
greatest hopes is that this
body of work may, in some
small way, contribute to
leaving a better world for you
and your generation.

CONTENTS

Foreword by Millee Tibbs — xi

Foreword by Dr. Mark K. Wourms — xii

Preface — xv

Acknowledgments — xvii

THE PLATES

AGOSERIS	2	CHIA	38
AMARANTH	4	CHICKWEED	40
AMERICAN LOTUS	6	CHIMING BELLS	42
AMERICAN SPEEDWELL	8	CHOKEBERRY	44
ANGELICA	10	CLOVER	46
ARROWLEAF BALSAMROOT	12	COW PARSNIP	48
ASPARAGUS	14	CURLY DOCK	50
AUTUMN OLIVE	16	DANDELION	52
BALLHEAD WATERLEAF	18	DESERT HOLLYGRAPE	54
BEDSTRAW	20	DESERT PARSLEY	56
BRACKEN FERN	22	DESERT TRUMPET	58
BROADLEAF PLANTAIN	24	EASTERN HEMLOCK	60
BUGLEWEED	26	EASTERN WHITE PINE	62
BURDOCK	28	ECHINACEA	64
CALIFORNIA POPPY	30	ELDERBERRY	66
CANADIAN VIOLET	32	FALSE SOLOMON'S SEAL	68
CATTAIL	34	FIELD MINT	70
CHESTNUT OAK	36	FIELD PENNYCRESS	72

FILAREE	74	LEMONADE BERRY	114
GILL-OVER-THE-GROUND	76	LEMON BALM	116
GINKGO	78	LICORICE FERN	118
GINSENG	80	LONDON ROCKET	120
GLACIER LILY	82	MAN-OF-THE-EARTH	122
GOOSEBERRY	84	MANZANITA	124
GREENBRIER	86	MARSH MALLOW	126
GROUND CHERRY	88	MARSH MARIGOLD	128
HEAL-ALL	90	MAYAPPLE	130
HEDGE MUSTARD	92	MESQUITE	132
HENBIT	94	MINER'S LETTUCE	134
HIBISCUS	96	MOCK STRAWBERRY	136
HOARY MOUNTAIN MINT	98	MONKEY FLOWER	138
HOOKER'S EVENING PRIMROSE	100	NETTLE-LEAF GOOSEFOOT	140
HOREHOUND	102	OXEYE DAISY	142
INDIAN CUCUMBER	104	PALE TOUCH-ME-NOT	144
ITHURIEL'S SPEAR	106	PALO VERDE	146
JOJOBA	108	PAWPAW	148
JUNIPER	110	PICKERELWEED	150
KENTUCKY COFFEE TREE	112	PINEAPPLE WEED	152

PRICKLY LETTUCE	154	SWAMP HEDGE NETTLE	192
PURSLANE	156	WALNUT	194
RASPBERRY	158	WAPATO	196
SALMONBERRY	160	WATERCRESS	198
SASSAFRAS	162	WATER LILY	200
SEA BEANS	164	WILD GINGER	202
SEGO LILY	166	WILD OATS	204
SHEEP SORREL	168	WILD OREGANO	206
SHISHO	170	WILD RADISH	208
SHOOTING STAR	172	WILD RHUBARB	210
SILVERWEED	174	WILD ROSE	212
SKUNK CABBAGE	176	WINTERGREEN	214
SOAP PLANT	178	WOLFBERRY	216
SOLOMON'S SEAL	180	WOOD NETTLE	218
SPICEBUSH	182	YAMPA	220
SPRING BEAUTY	184	YELLOW BELLS	222
STONECROP	186	YELLOW WOOD SORREL	224
SUMAC	188	YERBA SANTA	226
SUNFLOWER	190		

FOREWORD

IN THE PRIMORDIAL SOUP OF early photography, before there were divergent branches of art and science, scientists were artful and artists were scientifically curious. In fact, the invention of photography was equal parts artistic and scientific. Perhaps this is why some of the first subject matter fixed into silver were botanical specimens: aesthetically captivating scientific illustrations.[1] In this way, Jimmy W. Fike's *Edible Plants: A Photographic Survey of the Wild Edible Botanicals of North America* is both anachronistic and radical.

It is so rare that visual art in the twenty-first century is useful (useful like a map or useful like a spork). Most contemporary art rails against practical usefulness. Art is useful in that it shapes us, informs us, provides transformative experiences, sure, but it is rarely ever practical. It might nourish our spirit but rarely our bellies. Fike's *Survey* does both.

The title clues us in that this project is not of our time; the images, both delicate and fecund, are a roadmap to a more sustainable relationship with our environment. Though the title conjures the loquaciousness of the era of photographic invention, the temporal displacement it suggests might not be one of looking back but of looking forward. With the looming threat of food insecurity caused by late-stage capitalism and climate change, this field book might very well be a survival guide.

Fike's images are protophotographic—the flattening and two-dimensionalizing that usually occurs through the camera lens happens *before* the photograph is taken. The specimens are laid out and pinned with the same care given to the placement of objects in a cabinet of curiosity. Once digitized, they are colorized to indicate which part is edible. They are useful but are also autonomous aesthetic objects. That Fike refers to himself as a conceptual artist suggests that the art object is only the starting point of this work. We can spend time devouring the rich chiaroscuro of the brightly colored foliage against the black background, but

[1]. See Anna Atkins, *Photographs of British Algae: Cyanotype Impressions*, 1843, and William Henry Fox Talbot, *Pencil of Nature*, 1844.

the "real" art happens when we see the weeds in the sidewalk as a snack between meals. While these may be beautiful images (and they are), they are functional, practical; they teach us to re-see our quotidian surroundings as an integral part of our ecosystem. They teach us what to eat.

MILLEE TIBBS
Associate Professor of Art and Art History
Wayne State University

SURVIVAL INVOLVES FOOD, WATER, SHELTER, avoiding predators, and identifying a mate for reproduction. Depending on the organism, these priorities may not fall in that order. Imagine trying to discover which plants are edible. For humans, this process took trial and error over generations—and the errors were at times fatal. Knowledge was passed down through word of mouth, songs, rituals, drawings, and eventually photographs.

Today we rely on the sciences of agriculture, medicine, and nutrition to guide our intake of plants—vegetables, herbs, spices, and drugs. We take plants and science for granted, but Jimmy Fike provides a door to keep that sense of discovery and a connection to nature alive. Finding an edible plant in a forest or even in your backyard unearths a deep human need for nature.

In the lineage of Euell Gibbons' *Stalking the Wild Asparagus* and Bradford Angier's *Feasting Free on Wild Edibles* and others, Fike's *Edible Plants* provides a beautiful, visual "taste" of wild edibles, encouraging each of us to begin our own quest of discovery and learning about plants.

As an artist in residence in 2016 at Bernheim Arboretum and Research Forest, Fike was able to continue his layered approach to edible plants. Walking the beautiful forests, fields, and gardens of Bernheim with Interpretive Programs Manager Wren Smith, Fike honed his knowledge of Kentucky's plants and their links to the land, people, and culture while contemplating plant ecology.

You cannot search and collect edible plants without immediately caring about their abundance or rarity and the health of the soil and environment in which they grow. This natural history layer was the base for Fike to collect, arrange, and photograph these plants. The layers continue with the viewing of the images. Observed through artistic photographs, nature's symmetry and complexity, perhaps the evolutionary process itself, is highlighted by the artful positioning of roots, stems, leaves, and flowers.

This collection of beautiful edible plants links us to folk wisdom and ecology but, most important, provides that door to nature. Walk through it! Perhaps the best start is to find broadleaf plantain, a common lawn "weed" that is actually a wonderful cooked green and simply an amazing subject in Jimmy Fike's artistic work. Enjoy your meal, enjoy nature!

DR. MARK K. WOURMS
Executive Director
Bernheim Arboretum and Research Forest

LEFT Anna Atkins, *Cystoseira granulata*. Cyanotype photogram, from *Photographs of British Algae: Cyanotype Impressions*, 1843.

RIGHT William Henry Fox Talbot, *Plate VII, Leaf of a Plant*. Paper negative contact print, from *The Pencil of Nature*, 1845.

PREFACE

"The greatest delight which the fields and woods minister is the suggestion of an occult relation between man and the vegetable. I am not alone and unacknowledged. They nod to me, and I to them."

RALPH WALDO EMERSON

THIRTEEN YEARS AGO I EMBARKED on this epic project, setting out to produce a continent-spanning photographic survey of wild edible plants. It is with great joy that I am able to present the fruits of this journey to you within these pages. In its infancy, I envisioned this series as a way to use photography as a tool that integrated viewers into their local, natural environments. As a new type of landscape photography that had concrete utility, it is an aesthetic that recognized the new possibilities of layered, constructed digital imaging and sought out novel, earnest strategies to support the environmental movement. After viewing these photographs, I envisioned people discovering afresh the plants that grow all around them, are often overlooked, or even worse, vilified as weeds.

The images are made with fidelity to the plants' actual appearance (but meticulously constructed) and as such can be used as guides for foraging. I have developed a system that makes the plants, and their colorized edible parts, easy to identify. These images are infused with the spirit of the potlatch. What could be more generous than art that directs people to free sustenance? Beyond this concrete use, I've tried to cultivate a rich, open experience that allows a viewer to catechize about our relationship to nature and commune with the mysteries of dependent origination and symbiotic evolution. The plants pictured are continuously locked in a cycle of birth and death, pulsating with color, hypnotically communicating their edibility while floating in an infinite space. Like psychopomps, they guide viewers through a psychological process of transformation into an engagement with a universal spirituality and broker conciliation.

ACKNOWLEDGMENTS

I'D LIKE TO ACKNOWLEDGE THE wonderful artists' residencies that have made this project possible. To Chashama North, the Coleman Center for the Arts, Jentel, Elsewhere Studios, Stonehouse, the Bernheim Research Forest and Arboretum, and Willapa Bay—thank you, thank you, what a gift you gave me with your unique landscapes and support. As a disclaimer, I feel compelled to say that I'm an artist, a photographer, not a botanist by training, and while I've researched and cross-referenced each of these plants assiduously, please double-check with other primary sources before ingesting any wild edible botanicals. As you research and learn, I'm sure you'll be amazed at the sheer number of plants surrounding you that humans have eaten or used as medicine for centuries, and gradually start to see the natural world in its truly numinous splendor. I encourage you to get to know these plants, to acknowledge them as beings and companions, and to use their bounties respectfully but fulsomely. And lastly, I would be remiss to not acknowledge and show gratitude to Native Americans for the great body of cultural wisdom passed down on this subject.

EDIBLE PLANTS

THE PLATES

AGOSERIS, MOUNTAIN DANDELION, *AGOSERIS GLAUCA*

Pictured is *Agoseris glauca*, one of ten species of *agoserises* found in North America. This perennial member of the daisy family is often found in dry meadows or other open sunny areas at higher elevations throughout the western United States. The yellow flowers and white puffballs (achenes) both resemble those of dandelions. The flower heads are solitary on a single peduncle that rises to a foot and a half in height from a basal rosette of stemless leaves. The leaves may be linear, lanceolate, or oblanceolate, growing to twelve inches in length. The flower is edible. The leaves can be eaten raw in salads or boiled as greens and the roots roasted or boiled. The milky sap found within the plant can be used as a gum substitute. Traditional medicinal uses include treatments for wounds, swelling, and wart removal.

AMARANTH, PIG WEED, *AMARANTHUS RESTOFLEXUS*

Amaranth is an annual herb native to tropical regions of the Americas and now is introduced and widely distributed across the United States, often found in fields, meadows, and waste ground along roadsides and even suburban sidewalks. Amaranth grows from one to nine feet tall on erect stems, and the vibrant green leaves are lance shaped higher up the stem and more egg shaped near the base. The seeds and flowers grow in narrow clusters on a large inflorescence, and the taproot is red. The plant has a long history of use by Native Americans as an important food crop and source of medicine. Young leaves can be added to salads, green leaves boiled as a potherb, and the small, black seeds parched, used as a flour, or eaten raw as a nutritious survival food.

AMERICAN LOTUS, *NELUMBO LUTEA*

An aquatic perennial herb found throughout the eastern half of the United States and in California, growing in lakes, ponds, bays, and other places with slow-moving water, American lotus, although native, is at times considered invasive due to its propensity to completely cover whole bodies of water. It can grow to ten feet tall, emerging from a large network of tubers in the mud, with a leafstalk that reaches the surface of the water and is attached to a large (up to thirty inches), round leaf with a petiole at the center. The pale yellow flowers are large, beautiful, showy, and short lived, with numerous elliptical petals ending in a gentle tip surrounding a prominent, vase-shaped yellow pistil and stamen. The fruit and seeds are found in a large cone-shaped head. This plant was an important staple crop for many Native American tribes. The young leaves and stalks can be cooked and eaten as a potherb. The seeds can be boiled, popped, ground for flour, or eaten raw when young. The roots can be eaten raw or boiled.

AMERICAN SPEEDWELL, AMERICAN BROOKLIME, *VERONICA AMERICANA*

Look for this herbaceous perennial native plant growing in creeks, streams, and other wetlands at low to moderate elevations across much of the United States, with the exception of the Southeast. As it is rhizomatous, if you find one, you'll often find a colony. Speedwell grows to heights of about three feet on smooth, round stems that are often reddish. The glossy green leaves are opposite, lanceolate to oval, and toothed. The small flowers grow in clusters and are four lobed, with two stamens, and range from blue to pinkish blue to nearly white. The flowers, leaves, and stems are all edible and high in vitamin C. American speedwell is most commonly eaten raw as an addition to salads but can also be cooked as a potherb. It has a peppery taste similar to watercress.

ANGELICA, SEACOAST ANGELICA, *ANGELICA LUCIDA, ANGELICA* SPP.

There are over twenty-five members of the angelica family found in the continental United States, all of which are edible. The specimen pictured is seacoast angelica, found along the Pacific Coast, in the northeastern United States, and in Virginia. In the eastern half of the country, *Angelica atropurpurea* is more common. This slow-growing biennial herb is a member of the carrot family. It grows in moist locations with fertile soil. Its alternate leaves grow on long petioles that clasp the stalk and are pinnately divided into toothed, lobed leaflets. The smooth stems are hollow and purple near the base. The small, white to green flowers have five petals and five stamens and grow on an umbel-like inflorescence of flat-topped clusters composed of smaller umbelettes. The whole plant is considered edible. The leaves can be eaten raw in salads, dried for tea, or used as an herb. The stalk can be peeled and eaten raw or cooked and used in a fashion similar to celery. The dried seeds can be ground and used as a spice. The root can be used to infuse liqueurs. Angelica's taste is reminiscent of anise, carrot, and parsley. Care should be used when handling this plant, as it may cause skin irritations due to the presence of furanocoumarins. Angelica often grows near, and vaguely resembles, deadly poison hemlock, so great care is recommended before harvesting.

ARROWLEAF BALSAMROOT, OREGON SUNFLOWER, *BALSAMORHIZA SAGITTA*

Arrowleaf balsamroot conspicuously dots the landscape in open, cool, dry areas at mid- to high elevations in the west, and eastward as far as the Dakotas. This perennial forb grows to two and a half feet from a large taproot. The numerous bright yellow flowers (reminiscent of sunflowers) and cluster of large, arrow-shaped, fuzzy basal leaves make the plant easy to spot and identify. Lewis and Clark famously observed Native Americans using the plant and collected it as one of their specimens. The whole plant is edible—leaves, stems, seeds, and root. The leaves can be eaten raw or boiled and the root roasted or steamed and pounded into a flour or used as a coffee substitute. The seeds can be eaten raw, roasted, or used as an oil. Traditional medicinal uses included treatment for respiratory issues, burns, headaches, stomachaches, and insect bites.

ASPARAGUS,
ASPARAGUS OFFICINALUS

A delicious and highly coveted perennial, this herbaceous plant is distributed widely across the United States. Wild asparagus can often be found along roadsides or near marshes in sunny but moist conditions. It is the same plant as the cultivated version found at your local grocery store but has escaped from the garden since originally being imported from Europe in the 1600s. Asparagus has been an important food crop dating to antiquity. When left to grow, the plant produces fernlike side shoots and can reach in excess of six feet in height. It produces small, greenish-white or yellow bell-shaped flowers and small, red berries. The nutritious young, tender shoots can be harvested in the spring and eaten raw, steamed, sautéed, or pickled. If you find a good spot to harvest asparagus, come back year after year. This plant can live and produce for upward of thirty years.

AUTUMN OLIVE, AUTUMN BERRY,
ELAEAGNUS UMBELLATA

Autumn olive was originally imported from Asia to be used as a landscaping shrub in places with poor soil and is now considered an invasive species in many places. Birds love the fruit, ensuring that the seeds become widely distributed, and the plant spreads prolifically. Look for a bushy shrub up to fifteen feet tall and nearly as wide. The alternate, oval-shaped leaves are dark green on top and a shimmering light silver green on the bottom. The gray to brown twigs have spines, and the flower is yellow and trumpetlike. The fruit is nutritious, high in vitamins A, C, and E and antioxidants, and quite good, tart to sweet, depending on the ripeness. The small, round, dark red berries are speckled with small, silver flecks and often grow in abundant clusters. The fruit can be eaten raw or boiled to create jams and sauces.

BALLHEAD WATERLEAF, WATERLEAF, *HYDROPHYLLUM CAPITATUM, HYDROPHYLLUM* SPP.

This perennial herb is native to the western United States, especially the Rocky Mountains and Pacific Northwest, found in shady, moist conditions—mountain slopes and thickets and among aspens. There are eight native species of waterleaf in North America; Virginia waterleaf is prevalent in the eastern part of the country. Ballhead is one of the smaller species of waterleafs. It grows to six inches from fibrous roots, with fuzzy, pinnately divided, lobed leaves on short, reddish stems. Its bell-shaped flowers grow on round heads and are pale purple-pink to white with five hairy calyx lobes and five long stamens, all growing close to the ground. The flowers are edible raw, though fuzzy and tasteless. The young leaves and shoots taste slightly of carrot and can be eaten raw or cooked as a potherb. The roots are edible when steamed or boiled.

BEDSTRAW, GOOSEGRASS, CLEAVERS, *GALIUM APARINE*, *GALIUM* SPP.

Bedstraw goes by many names, and the *Galium* genus contains many species spread throughout the world, many with long histories of human uses as food and medicine. *Galium aparine* is widespread throughout most of North America, often found in moist, disturbed soil. One of the most easily recognizable characteristics of bedstraw is its numerous Velcro-like hooks that make the plant cling to clothes. The creeping stems can grow to three feet. The leaves grow in whorls of six to eight and are fairly evenly spaced along the stem. The small, greenish or white star-shaped flowers grow in small clusters emerging from the leaf axils. Young leaves and stems can be eaten raw, but older plants become covered in hooks that can irritate the digestive tract, so they are best cooked as a potherb. The roasted seeds make a good coffee substitute, and a tea can be made from dried leaves. Historically, bedstraw has been used to treat a wide range of ailments—tumors, scurvy, coughs, asthma, and kidney problems—and as a poultice for wounds.

BRACKEN FERN, *PTERIDIUM AQUILINUM*

Bracken ferns can be found across most of the United States, though sparsely in the Great Plains, and range over most of the earth. This ancient plant has been around for over fifty million years, and humans have used it for food for millennia. It can be found in woodlands and disturbed sites and on hillsides with moist soil. It grows to over six feet in height from a deep rootstock and is most distinguishable from other types of ferns by its fronds, which fan out in groups of three from an erect single stalk. The leaves are roughly triangular in shape and subdivided into many opposite, round-toothed leaflets. The immature fronds, or "fiddleheads," are edible; make sure to harvest them before the fronds unfurl. The fiddleheads taste of almonds and asparagus and are high in vitamin A, but the plant also contains ptaliquilosides, a known carcinogen. Soaking the plant in water and cooking it is thought to remove the toxins. It is advised to eat this plant in moderation. The rootstock, though fibrous, can also be eaten—boiled, roasted and pounded into a flour, or used to flavor candies and beer. Additionally, bracken ferns have long been used medicinally to treat headaches, worms, diarrhea, hair loss, burns, and clogged breast ducts.

BROADLEAF PLANTAIN, COMMON PLANTAIN, *PLANTAGO MAJOR*

Plantain is one of the most common and ancient wild edible plants, readily found in lawns and moist, disturbed soils and along roadsides in every state. Originally cultivated in Europe, it quickly spread across the United States following in the wake of white colonialists moving westward, earning the nickname "white man's footprint" from Native Americans. Depending on your region, you may find broadleaf, common, and/or narrow-leaf plantain (or one of the two hundred other species of *plantago*). Plantain is a highly nutritious plant containing vitamins C, A, and K, iron, and calcium. The leaves are elliptical to egg shaped with parallel veins growing in a rosette. The small flowers and seeds are borne on a series of slender spikes growing from the center of the plant. Young, tender leaves and shoots can be eaten raw, but the older, tougher leaves are best boiled or steamed. The seeds, though very small, are also edible. Medicinally, plantain has been used as an expectorant, anti-inflammatory, antihistamine, and a laxative and as a treatment for a variety of skin problems.

BUGLEWEED, NORTHERN BUGLEWEED, *LYCOPUS UNIFLORUS*

Bugleweed is a perennial herb growing from a rhizome and is a member of the mint family. It can be found throughout the United States but is more abundant in cooler climates. It grows in wet soils; bogs, marshes, and edges of ponds are great places to search. The plant grows to two feet tall and has a square stem (characteristic of the mint family), coarsely toothed opposite leaves, and small, tubular, white flowers that grow in dense clusters at the leaf axils. The leaves, tubers, and roots are all edible. The leaves may be eaten raw or cooked as a potherb but aren't considered particularly palatable. The roots and tubers, considered an important food crop for many Native Americans tribes, can be eaten raw, cooked, or dried and stored for later. Traditionally, bugleweed has been used medicinally to treat coughs, thyroid problems, and heart palpitations and as a sedative.

BURDOCK, GREATER BURDOCK, GOBO, *ARCTIUM LAPPA*

There are three species of burdock found in North America: greater (pictured), woolly, and lesser, all of which are edible. Burdock is a widely distributed biennial plant often found in a sunny location with disturbed soil. During the first year, the leaves grow in a basal rosette. These young plants are considered the best to eat. In the second year, the plant grows much taller, up to ten feet. The large, heart-shaped, green leaves are wavy and whitish on the underside. The taproots can grow to great size and depths. Its flowers are purple and thistlelike, growing from a bristly capitula. One of burdock's most notorious parts are the brown achenes, or burrs, that cling tenaciously to animal fur and human clothing. Young roots can be peeled and eaten raw, sautéed, boiled, roasted, and pickled or used to make a root beer. Young shoots, stems, and leaves can be boiled as a potherb. Burdock is also known to have antibacterial and anti-inflammatory properties.

CALIFORNIA POPPY, GOLDEN POPPY, *ESCHSCHOLZIA CALIFORNICA*

A perennial plant native to much of the west and southwestern United States, poppies grow to two feet tall from a taproot in sunny, well-drained locations: dry fields, valleys, and hillsides. When in bloom, its beautiful yellow to orange flowers enliven many western landscapes with a golden glow. Its leaves are blue green and reminiscent of parsley, branching and alternately divided with finely lobed leaflets. The flowers grow from a small, pink disk and are four petalled, cup shaped, up to four inches in diameter. The flowers open with the light and close in dark or overcast conditions. The small, elongated seedpods contain the black seeds poppies are known for. The flowers can be used raw as a decorative addition to salads or dried to make tea. The small seeds are also edible. The plant has a long history of medicinal use by Native American tribes and was used as a sedative and to treat stomachaches, toothaches, and headaches.

CANADIAN VIOLET, CANADIAN WHITE VIOLET, *VIOLA CANADENSIS*

Canadian White Violet is a widely distributed perennial plant found in deciduous forests throughout North America. In other areas of the country, wild violet (*Viola odorata*) is more common and often found in lawns but is similar in edibility. Canadian violet emerges from a fibrous root, reaching a height of approximately one foot, has heart-shaped, palmate, finely toothed leaves, and has distinctive white flowers with five petals and a yellow center with small, dark lines on the lower petals, growing on a leafless stalk. The edible leaves and flowers are high in vitamins C and A, making a nice addition to salads, or can be added to soups as a thickening agent. The dried leaves and flowers can also be used to make tea and the flowers used to flavor candies and jellies. Medicinal uses for violet include as a poultice for skin irritation, alleviation of bladder pain, and as an emetic.

CATTAIL, *TYPHA LATIFOLIA*

A perennial plant emerging from water and growing to eight feet in height, cattail is found in ponds, streams, ditches, marshes, and other aquatic environments throughout the United States, at elevations under eight thousand feet. Cattails are one of the great wild edible plants due to their ubiquity, versatility, and ease of recognition. They grow from a rootstock sending up a tall, erect stalk with swordlike, stiff leaves, with a slightly rounded back. The stalks are topped with a dark brown cylindrical head, or catkin, covered with minute flowers, male on the top half and female on the bottom, later in the season becoming covered with pollen. The starchy, fibrous roots are edible and can be boiled or roasted and ground to extract flour. The crspy, young edible shoots and stalks are nutritious, containing vitamins A, B, and C, and can be cooked like asparagus or eaten raw. The pollen is high in protein and can be collected and used as flour in baked goods. The green, immature catkins can be eaten like corn on the cob. Cattails can also be used as a fire starter, to make shelter, and as bedding.

CHESTNUT OAK, *QUERCUS PRINUS*

This type of white oak is found in dry woodlands and on rocky slopes across the eastern United States. It grows to approximately seventy feet tall, producing a shady canopy in forests and on ridgelines. Its bark is dark in color, with deep ridges, and leaves grow to nine inches with a series of rounded teeth along the edge. It produces large, edible acorns—growing to an inch long. Most oaks produce acorns high in tannins, a bitter chemical that needs to be leached from the nut before eating. Once the tannins are removed, the acorns can be roasted, candied, added to stews, or ground into a flour. Acorns are high in fat and protein and considered an important food source for many Native American tribes. Across the United States, there are ninety species of oak, all of which produce edible acorns, but with varying degrees of palatability.

CHIA, DESERT CHIA, CHIA SAGE, *SALVIA COLUMBARIAE*

Chia can be found in undisturbed sites at lower elevations across much of the southwestern United States and prefers dry, sunny climates. The plant is small, up to about one and a half feet in height. It has a basal rosette of wavy, grayish-green, oblong, pinnately divided leaves. The most recognizable characteristic of the plant is the succession of bracts with spheres of small, purple flowers. This plant was an important source of food and medicine for Native American tribes and is highly nutritious, versatile, and useful. The seeds of the plant can be eaten raw or roasted and used to make cakes and porridges, used as an addition to other flours, soaked in water to make a drink, or sprouted for greens. The leaves may also be used as seasoning. Medicinally, chia has been used as a poultice to treat wounds, reduce fever, and heal eye infections.

CHICKWEED, *STELLARIA MEDIA*

A sprawling, matted annual plant found in disturbed soils, fields, and shaded lawns, chickweed, despite being small in stature, grows to sixteen inches and puts down new roots from its stems, allowing the plant to grow in dense colonies. Its weak stems have one defining characteristic: a thin, single line of small hairs running up the side. The leaves grow to one and a half inches, opposite, oval but ending in a sharp tip. Leaves near the base of the plant have petioles; the upper ones do not. Its small, white flowers grow in terminal clusters and are five petalled, but appear as ten due to the deep clefts that split each petal. Young leaves are edible raw in salads. The shoots and leaves are mild in taste and can be boiled, steamed, sautéed, and in general prepared and used like spinach. Dried leaves are used to make tea. Chickweed has a long history of medicinal use in Europe, where it originated. It has been used to treat skin irritations, acne, earaches, headaches, constipation, and hoarseness.

CHIMING BELLS, MOUNTAIN BLUEBELLS, *MERTENSIA CILIATA*

This perennial herb grows to approximately two feet in height and is common to moist environments like meadows and bogs and along streams in mountainous regions of the western United States. The plant is covered with blue-green alternate leaves that range in shape from elliptical to lanceolate to ovoid, all with pointed tips, growing on a cluster of stems rising from the root. The tubular, bell-shaped flowers have a lobed mouth, are fragrant, and hang from an inflorescence, ranging in color from pink to blue. The flowers are edible raw as a sweet, floral trail nibble or an addition to salads. The leaves are edible raw but covered with fine, unappetizing hairs. To remove the hairs, the leaves can be boiled as a potherb. Medicinally, an infusion of the plant has been used to improve breast milk production and to reduce itching.

CHOKEBERRY, BLACK CHOKEBERRY, *ARONIA MELANOCARPA*

A native deciduous shrub common to eastern North America, chokeberry has a rounded profile and grows to eight feet in height. It produces leaves that are dark green and glossy on the top with a lighter tint of green underneath, oval in shape, finely toothed at the margins, and grow to two inches in length. When in bloom the plant is covered with clusters of five-petalled, white flowers with pink stamens. The shiny, round, black fruit is rich in antioxidants, grows to one-half inch, contains up to five small seeds, and dangles in bunches from red, many-branched stems. It is edible raw but often is too bitter and tart to be enjoyed (hence the "choke" in the name). Most often the fruit is sweetened with sugar and used to make jams or desserts. Within the Aronia family, you can also find edible red and purple chokeberries.

CLOVER, RED CLOVER, *TRIFOLIUM* SPP.

Clover is a widespread and common perennial found on lawns, fields, and roadsides across much of the country and most of the world. Clover creeps along the ground, dropping stolons as it spreads, with only the flowers growing erect. The leaves are divided into three leaflets (occasionally four, if you're lucky) with numerous tubular florets growing on a globe-like flower head full of nectar that attracts bees. The entire plant is considered edible but often comes with warnings about possible allergies and the presence of trace amounts of cyanide and to never eat it fermented. The plant is high in vitamin C, protein, and B vitamins. The raw leaves can be eaten in moderation but aren't considered choice. The leaves cooked as a potherb are more palatable. The flowers can be eaten raw. The dried flower heads can be ground into a flour or used for tea.

COW PARSNIP, *HERACLEUM LANATUM, HERACLEUM MAXIMUM*

This perennial herb is a member of the parsley family that can grow to ten feet tall and is found throughout most of North America, excluding a few southern states. It grows in moist, shaded locations: meadows, bogs, ditches, and riparian corridors. The plant gives off a pungent odor. Its leaves are large, up to twelve inches, toothed, and deeply, palmately lobed, divided into three sections, and clasped onto the hollow stalks. Its small, white flowers grow on a large umbrellalike disk that is subdivided into umbelettes. Its small fruit is flat, winged, and papery with black lines. Young stems can be peeled and eaten raw, boiled, steamed, or sautéed and taste like celery. The large roots can be prepared like parsnips but often retain a pungent taste. The base of the plant can be dried and ground, and the leaves dried and turned to ash as a salt substitute. It also has a long history and myriad applications as a medicinal plant. It has been used to treat asthma, epilepsy, sore throats, headaches, coughs, colic, cramps, diarrhea, boils, and sores. Caution is recommended when harvesting this plant, as it can cause dermatitis and is related to deadly water hemlock.

CURLY DOCK, SOUR DOCK, *RUMEX CRISPUS*

Curly dock, and related *Rumex* species, are widespread throughout North America, found in fields, along roadsides, in meadows, and in other disturbed soils. The plant grows upright from a large yellowish taproot and reaches five feet or more in height. Curly dock has long, very wavy, lance-shaped alternate leaves with a papery sheath where connected to the stem. It has inflorescences of small, green flowers that grow on multiple spikes. The young leaves may be eaten raw in salads, but due to the presence of oxalic acid, it is often recommended that the leaves be boiled as a potherb before consumption. The leaves are sour in taste, high in vitamins A and C, and a good source of potassium and iron. The ground seeds can be used to make meal or dried and used as a tobacco substitute. Medicinally, dock has been used to treat numerous ailments: skin problems, diarrhea, anemia, constipation, sore throats, dysentery, enlarged lymphoid, and rheumatism.

DANDELION, *TARAXACUM OFFICINALE*

Dandelions are often considered the most useful and versatile of all "weeds" that populate lawns across the United States. It is widespread and ubiquitously found in most all types of disturbed soil across much of the world and has an ancient history of use as food and medicine. The plant is easily recognized by its yellow flowers growing on clustered heads of ray florets on a single, hollow, leafless stalk. Later in the season, the flowers transform into the white puff balls of wispy parachutes, or achenes, that kids delight in blowing. The leaves are all found at the base of the plant and are lobed, toothed, oblanceolate, and end in a tip. When broken open, the leaves release a milky latex. Dandelion grows from a taproot to a foot in height. The young, highly nutritious leaves can be eaten raw in salads. Often the leaves get more bitter with age, so they are boiled in changes of water before eating. The dried leaves can be used for tea. The taproot can be sautéed, roasted, boiled, or dried and ground to make a coffee substitute. Wine can be made from the flower heads and fritters made from the buds.

DESERT HOLLYGRAPE, RED BARBERRY, OREGON GRAPE, *MAHONIA* SPP.

Desert hollygrape can be found across drier areas of the southwestern United States, from the Sonoran Desert to higher elevations that include juniper-oak ecosystems. The medium-sized shrub grows to twelve feet in height and is covered with alternate, pinnately compound, waxy, toothed evergreen leaves with sharp, thorny tips (similar to holly bushes often found in landscaped yards). Its flowers are small and yellow and grow in erect clusters of up to seven. The inner bark is yellowish. The plant produces large quantities of deliciously tart berries that are high in vitamin C. These small, round berries range in color from yellow to orange and red. They may be eaten raw, turned into jam, or dried and stored for later use. The roots are highly microbial and have been used medicinally to treat liver conditions, aid in digestion, regulate blood sugar, and treat wounds.

DESERT PARSLEY, BISCUIT ROOT, *LOMATIUM* SPP.

This is a small perennial plant, growing to twelve inches in height, found in sagebrush desert ecosystems and dry, open plains throughout much of the western United States. There are over eighty members of the Lomatium family. This plant is one of the first green growths of spring. Desert parsley has long, thin, fibrous roots that grow to twelve inches and are covered with a black skin. Some other varieties of Lomatium have short, rounder roots. Its flowers are small and yellow, white, or, rarely, maroon and grow in compound umbels. The leaves are fernlike, growing from the base of the plant and pinnately dissected. The roots are edible and can be consumed raw, roasted, or boiled. A type of cake called a kohn can be made from desert parsley flour and was a traditional food for many Native American tribes (as famously noted by Lewis and Clark). Some members of the parsley family are quite toxic, so take care to positively identify this plant before ingesting.

DESERT TRUMPET, INDIAN PIPEWEED, *ERIOGONUM INFLATUM*

This perennial member of the buckwheat family can be found in dry, sunny areas of the desert Southwest at low to mid-elevations. Desert trumpet is known for, and easily identified by, its hollow, swollen stems—hence the reference to "trumpet" in its name and use as a pipe and drinking straw. The swollen stems hold carbon dioxide and aid in photosynthesis. This plant grows to about three feet in height and has panicles of small, pink or yellow flowers. Its wavy, woolly, ovoid to scallop-shaped green leaves grow in a basal rosette. The spindly stems shoot up vertically and are green to the swollen bladder, then branch off and often become brownish. Young leaves and stems can be eaten raw or boiled and the seeds dried and eaten whole or ground into a flour.

EASTERN HEMLOCK, CANADIAN HEMLOCK, *TSUGA CANADENSIS*

This tree is a long-lived, needled evergreen in the pine family found in shady, cool, humid, well-drained environments in the northeastern United States, ranging southward through the Appalachian Mountains and in the upper Midwest. It can grow to one hundred feet in height with a diameter of four feet on its long, straight trunk with brown, deeply fissured bark and a conical profile. The shiny needles are short, less than an inch, flattened, with two white bands on the underside and fine teeth. They are densely arranged on opposite rows of bumpy twigs. Eastern hemlock produces small elliptical-to-ovoid cones that change from yellow green to light brown and hang downward. The needles are high in vitamin C and can be chewed as a trail nibble or brewed to make a nutritious, but bitter, piney tea. This tree is not related to notorious poison hemlock, a deadly herbaceous perennial.

EASTERN WHITE PINE, *PINUS STROBUS*

The eastern white pine is a needled, fast-growing evergreen tree native to the eastern United States and found in mixed forests. White pines can live for over five hundred years and are often the tallest tree in the forest, growing to over two hundred feet, with a trunk five feet in diameter and a plumelike profile. The trunks are many branched. The needles grow to four inches long in fascicles, or bundles, of five from a brown sheath. Its cones are elongated and grow to six inches, with round-tipped scales. White pine has a multitude of beneficial uses as food, medicine, and craft. The plant is very high in vitamin C. The needles can be brewed to make tea. The inner bark was often dried to make flour or used as a survival food. Young pine cones can be used as a spice in soups and stews. Pine nuts are edible raw or roasted. The pollen can be used as flour or a thickening agent. The resin can be chewed or dissolved in water to make a beverage. Pines constitute a large genus, with many types found across the country, and while many are edible, several are not, so make sure to research the specific pines found in your region before consuming.

ECHINACEA, PURPLE CONEFLOWER, *ECHINACEA PURPUREA*

This perennial herb grows in sandy, rocky soils in meadows and prairies and along roadsides in the eastern and midwestern United States ranging into Texas and Colorado and has become a favorite in cultivated gardens. It grows to three feet tall on stout stems, with pink or purple elliptical, daisylike flowers growing around a spiked cone head. The flowers are often slightly downturned. The leaves are dark green, ovate, and toothed with white hairs. The flowers and leaves are considered edible and can be dried and used to brew tea. Echinacea is more commonly thought of as a medical plant, with the tea or a tincture being used to treat pain, aid the immune system, treat skin aliments as an analgesic and antibacterial, and treat insect or snakebites.

ELDERBERRY, BLUE ELDERBERRY, *SAMBUCUS CERULEA*, *SAMBUCUS MEXICANA*

This deciduous shrub is large, growing to thirty feet in height with a wide, many-branched profile. It is found in abundance along the Pacific Coast and more sporadically throughout the western United States in well-drained soils with light moisture: canyons, hillsides, streambanks, and sage scrub ecosystems. The leaves are pinnately compound and elliptical to lanceolate with serrated edges, a sharp tip, and an asymmetrical base. The umbel-shaped, cream-colored flowers are strongly scented and grow in clusters. The round, bluish-black fruit is coated with a waxy white powder and grows in drupes. The berries are delicious, high in vitamin C, and versatile but when raw or uncooked contain toxic alkaloids. The berries can be used to make wine, cook in pies, or make jam preserves. The flower heads can be battered and fried. Additionally, the plant has long been used by Native Americans for its medicinal properties and for various crafts. Common elderberry, or *Sambucus canadensis*, is similar in edibility and grows east of the Rocky Mountains.

FALSE SOLOMON'S SEAL, *SMILACINA RACEMOSA*

This perennial plant is common to moist, partially shady, montane environments, in coniferous forests of the western United States and the deciduous forest of the east ranging into Tennessee and North Carolina. It grows to three feet in height and is similar in appearance to Solomon's seal. Its lone arching stem rises from a slender, yellowish rootstock with round "seals." It has veined, alternate, oval leaves with pointed tips. The small, star-shaped flowers are white, cream, or greenish in color and grow on a long raceme. It produces small, white berries with specks of gold. Later in the season, the berries turn dark red. Young shoots can be eaten like asparagus: raw, steamed, or sautéed. The berries and rootstock are also edible, but with caveats. The bitter roots should first be soaked in lye and then parboiled, and can be pickled. The berries are purgative, so they should only be eaten in small quantities; cooking reduces their purgative effects.

FIELD MINT, CORN MINT, *MENTHA ARVENSIS*

Field mint is the only mint native to North America and is widely distributed in moist, temperate regions throughout. Look for this mint near streams and rivers, growing in abundant patches from a creeping network of rhizomes. The plant grows to about two feet and has the characteristic square, hairy stems of the mint family. The leaves grow in opposite pairs up to two inches long, with serrated edges, and smell strongly of peppermint when crushed. The purple, white, or pink flowers are small and trumpetlike, growing in whorls around the leaf axils. The leaves may be eaten raw, used as spice or flavoring, and dried to make a soothing tea. The oil can be extracted to create a tincture and medicinally has been used to treat upset stomachs and fevers and for dental care. The plant is also known to repel insects.

FIELD PENNYCRESS, *THLASPI ARVENSE*

This annual herb is a member of the mustard family. It originated in Europe but is now widely distributed across the United States, found in fields and disturbed soils and along roadsides. It grows to three feet in height on smooth, yellow-green branched stems. It produces narrow basal leaves that wither and die before the plant flowers. Attached along the stem, you'll find lance-shaped, wavy leaves lobed at the base. It produces small, four-petalled, white flowers that grow in clusters. The "penny"-like seed heads are distinctive: round and flat with a heart-shaped notch at the tip and a bulge in the center that contains small, black seeds. Young leaves can be eaten raw but often have an overpoweringly bitter mustard flavor. Young shoots and leaves are high in vitamin C and can be boiled or sautéed to reduce bitterness. The seedpods can be used as a spice in soups.

FILAREE, STORK'S BILL, *ERODIUM CICUTARIUM*

This plant is an annual or biennial herb (depending on the climate) in the geranium family, growing to two feet but often laying prostrate. Native to North Africa and Eurasia, it was introduced by Spanish explorers to California in the 1700s, where there are still large populations of the plant, and now is found throughout the United States in grasslands, plains, disturbed soils, riparian areas, forests, and lawns. When young, the leaves grow in a basal rosette attached to a small taproot. Older plants have pinnate, fernlike leaves that can grow to four inches. The whole plant is covered in fine, white hairs and is sticky to the touch. Its flowers are pink with five elliptical petals. Stork's bill gets its name from the long beak-like seedpods that grow in small clusters. The whole plant is considered edible. Young leaves are edible raw or cooked as a potherb and taste of parsley. The root makes a gum substitute. When young, the plant bears some resemblance to poison hemlock, so take great caution when harvesting.

GILL-OVER-THE-GROUND, GROUND IVY, CAT'S FOOT, *GLECHOMA HEDERACEA*

This perennial and member of the mint family can be found growing in sprawling mats as ground cover in lawns, along hedgerows, and in other moist areas throughout most of the continental United States (excluding the desert Southwest). The plant has a long history of use in Europe before being introduced here by colonists. It has square stems, and the runners put down roots as it sprawls. Its scalloped leaves grow to about one inch and resemble a cat's paw. The flowers are bluish violet and trumpet-shaped. The plant was used historically to aid in brewing beer, and its peppery leaves and flowers are edible raw, cooked as a potherb, fried, or dried to make tea. Traditionally, it has been used medicinally to treat tinnitus swelling, bruises, and congestion in the sinuses and lungs.

GINKGO, *GINKGO BILOBA*

This remarkable tree is the lone surviving member of the Ginkgoales family, ancient trees dating back over two hundred million years. It was introduced to the United States from China and is primarily used for landscaping in areas with moist, deep soil and full sun. It can grow to over seventy feet in height and forty feet in width and live more than four thousand years. Its bark is gray to brownish gray and becomes deeply furrowed with age. Its leathery leaves are fan-shaped with two lobes and parallel veins that fan outward from the stem, and grow to three inches in length, turning golden yellow in the autumn. The seeds are edible, but only after the putrid orangish fruit surrounding it is removed. Once cleaned, the seeds can be roasted or boiled. The seeds should be eaten in moderation and gloves used when harvesting to avoid skin irritation.

GINSENG, AMERICAN GINSENG, *PANAX QUINQUEFOLIUS*

A perennial plant found in rich, moist, deciduous forests in the eastern United States, with clusters of prevalence in the Ozark and Appalachian Mountains, ginseng can be found in shady environments and grows to eighteen inches tall, with three palmately compound leaves—often divided into five toothed leaflets. An umbrel of small, greenish-white flowers grows from the whorl, turning into red berries. The flowers and berries are fragrant. The root has long been used by Native American tribes for its medicinal properties. The roots and leaves are considered edible and can be added to stews or soups. The dried roots and leaves can be brewed as tea or used for medicinal purposes. Ginseng is classified as threatened or endangered in many areas and takes years to mature—care is recommended before harvesting.

GLACIER LILY, AVALANCHE LILY, SNOW LILY, *ERYTHRONIUM GRANDIFLORUM*

This is a perennial member of the lily family, found in moist meadows and on slopes and other open areas at mid- to alpine elevations across the montane west and northwestern United States. The plant grows to twelve inches in height from a corm deep in the soil. It has two wavy, veined, oblong basal leaves that grow to eight inches long. The vibrant yellow flowers are nodding, with six petals that curve back upward, and six stamens. The corms were an important source of food for many Native American tribes. They can be eaten raw in moderation but may cause vomiting. They are considered more palatable with some preparation, either roasted, boiled, or steamed. They were often dried, stored, and reconstituted before cooking, becoming darker and sweeter to the taste. Medicinally, the roots and corms were used to treat colds and boils and as an antiseptic leaf tea to treat cuts and sores.

GOOSEBERRY, *RIBES* SPP.

Ribes is composed of a large family of gooseberries and currants with over one hundred species dispersed widely across North America. They grow in a variety of environments but prefer cool climates with moisture: mountain forests and foothills. All are considered edible but with varying degrees of palatability. Look for an erect or sprawling shrub with thorny branches; some, like the western gooseberry, even have thorny berries. The leaves are distinctive and consistent throughout the species: alternate, maple, or goose-foot-like, with three to five lobes, and grow to two inches wide. The flowers are white to greenish, tubular, and spring from the leaf axils with five petals and five sepals. The round berries turn from green to yellow, orange red, or black when ripe, depending on the species, and have a small "tail" hanging from the bottom side. The berries are tart, high in vitamin C, slightly sweet, and quite versatile. They can be eaten raw, baked in desserts, used to make jam, blended for drinks or sorbets, or dried for later use. Medicinally the plant has been used as an antiseptic and to treat colds and yeast infections.

GREENBRIER, *SMILAX ROTUNDIFOLIA*

A woody perennial vine common to woodlands and margins of cultivated and disturbed lands in the eastern United States, greenbrier grows vertically from a large network of rhizomes, often in thickets and up trees, and is capable of reaching heights of fifty feet or more. Its green, woody stems are covered in thorns, and the alternately branching leaves are green, waxy, and broadly heart-shaped, with parallel veins growing to six inches long with tendrils growing from the axils. It produces small, green or white flowers and dark, round berries. The tendrils and young leaves can be sautéed or steamed and the small roots boiled and eaten. Older roots can be dried and ground into a thickening agent for soups or used as a beverage. It was once used to make sarsaparilla. The berries are considered valuable as a winter survival food.

GROUND CHERRY, HUSK TOMATO, TOMATILLO, *PHYSALIS* SPP.

Plants in the genus *Physalis* are herbaceous, flowering members of the nightshade family, over seventy-five species of which are native to the Americas. Ground cherry can be found in a variety of habitats but prefers sunlight, warm temperatures, some moisture, and can commonly be found in disturbed soils. It grows to three feet in height on erect, many-branched stems with broadly heart-shaped, gently toothed, hairy, wavy leaves. As it is in the same family as tomatoes, it can often be identified using those similar characteristics—the overall size, leaf shape, and fruit resemble those of tomatoes. The most unique characteristic of ground cherries are the paper lantern–like husks that surround the round fruits. The ripe fruit is yellow orange, has a tart to sweet flavor, and can be eaten raw, used to make jam and salsa, or dried for later use—or used in any manner similar to tomatoes.

HEAL-ALL, SELF-HEAL, *PRUNELLA VULGARIS*

Heal-all is a low-growing member of the mint family native to North America, usually less than one foot tall, and can be found in temperate climates across much of the continent. It prefers moist sites like roadsides, meadows, and creek sides. Like other mint species, it has a square stem. The opposite leaves are lance- to oval-shaped. The stems terminate in an oblong spike covered with a whirl of small purple or blue flowers, with a hood above a three-lobed lip. The whole plant is edible and can be prepared as a potherb. The leaves and flowers can be used the way one would mint, for flavoring or tea. As one can infer from the name, heal-all is mostly known for its medicinal purposes. Among its many benefits, this plant has been used to dress wounds, stop internal bleeding, and alleviate sore throats, diarrhea, venereal disease, fever, heart problems, acne, and hemorrhoids.

HEDGE MUSTARD, *SISYMBRIUM OFFICINALE*

Hedge mustard is native to and was cultivated in Europe and North Africa. Since then, this annual herb in the cabbage family has spread across the globe, including most of North America. It is found in fields, along roadsides, and in disturbed soils, growing to two feet tall with many hairy stalks. The dark green leaves are hairy, alternate, and pinnately lobed, with a large triangular lobe at the top of the leaf. The upper leaves are often a singular lobe. The small, yellow flowers with four petals grow on erect stems that rise above the leaves. The leaves are edible raw in salads but are strong in flavor, or they can be cooked as a potherb. The seeds may be ground to create a "mustard" or to extract oil. The plant, and especially the seeds, contain glycosides that affect the heart. Care should be used when harvesting this plant, especially among people with heart conditions. This plant has a history of medicinal use dating to antiquity.

HENBIT, *LAMIUM AMPLEXICAULE*

This favorite snack of chickens is an annual plant in the mint family found in cool, moist areas: fields, roadsides, lawns, and other disturbed soils throughout the United States. It grows on square stems to a height of fifteen inches from a fibrous system of roots, and despite its family affiliation doesn't smell minty. The opposite, heart-shaped leaves have rounded teeth and are wrinkly with fine hairs, growing in pairs on either side of the stem. On the bottom half of the plant, the leaves grow from petioles. The small pink or violet flowers with spots on the bottom lip grow from leaf axils at the top of the plant. The stems, flowers, and leaves are all considered edible and taste of kale. The nutritious leaves are most commonly eaten raw in salads but can be cooked as a potherb or dried for tea. Medicinally it has been used as a laxative, as a stimulant, and to reduce fever and inflammation.

HIBISCUS, ROSE OF SHARON, *HIBISCUS SYRIACUS*

This deciduous shrub originated in China but is now widely distributed across the United States, commonly used for landscaping in gardens and other suburban areas in warm climates. It is just one member of a large family of hibiscuses, most of which have some degree of edibility. The shrub grows to thirteen feet in height and sends out straight, lengthy, gray stems that originate just above the ground. It produces large, showy flowers with five petals that bloom and last for just a day, but often in quick succession from numerous buds. The flowers are large, papery, and wavy at the margins, with long tubelike stamens, and range in color from pink to pale blue, white, red, and violet. The leaves are three lobes with the center leaflet the longest, coarsely toothed at the margins. Leaves can be eaten raw in salads but are mucilaginous. The flowers and flower buds can also be eaten raw or added to salads. The buds can be sautéed or fried. A tart and commercially available tea is made from the dried flowers and leaves.

HOARY MOUNTAIN MINT, MOUNTAIN MINT, HORSE MINT, *PYCNANTHEMUM INCANUM*

This evergreen, perennial herb is native to North America and grows in the eastern half of the United States, ranging as far west as the Dakotas. It can be found in sunny locations such as old fields, meadows, roadsides, thickets, and along the edges of forests. It spreads from a rhizome to five feet tall from multiple vertical stems and is branched near the top with broad, deeply veined leaves up to three inches long. The leaves near the top of the plant are covered with short, fine hairs, giving them a whitish or "hoary" appearance. It produces a half-domed or flat umbel of white to lavender flowers that have a spot on the lower lip and grow to one-half inch. A disk of lance-shaped leaves grows beneath the flowers. When crushed, the plants smell strongly of menthol. The leaves and flowers can be eaten raw as a flavorful addition to salads, cooked as a potherb, or used as a spice in soups or to flavor meats. The dried leaves and flowers can be used to make tea. This plant, like many mints, has a long history of medicinal use and a plethora of applications: expectorant, analgesic, sedative, and antiseptic, to name a few.

HOOKER'S EVENING PRIMROSE, WESTERN EVENING PRIMROSE, *OENOTHERA ELATA*

This species of evening primrose is found in the western United States in moist meadows, near streams, and along roadsides. Like other evening primroses, its flowers open at dusk and wither by morning. The plant is biennial and, during the first year, produces a basal rosette of lanceolate leaves and a large root. During the second year, it grows prodigiously on erect, reddish, hairy stems reaching six feet in height. The fragrant yellow flowers, which turn orange with age, are about three inches wide, have four heart-shaped petals, and grow in succession along the stems. Across the country you can find many more species of evening primroses in the genus *oenothera* that have similar edibility. The leaves of the young plants can be eaten raw or cooked as a potherb. The flowers can be added to salads, the seedpods steamed, or the small seeds collected and ground for flower or oil. The large taproots are comparable to parsnips and edible when boiled.

HOREHOUND, *MARRUBIUM VULGARE*

This perennial herb is native to Europe, Asia, and North Africa and now is found in pastures, disturbed land, and other dry, sunny, well-drained locations throughout most of the continental United States. It grows to three feet on branched clusters of white, woolly, square stems. The opposite, egg-shaped leaves are grayish, toothed, and wavy, with fine hairs and longer petioles on leaves near the base of the plant. Its small, tubular, white flowers are two lobed and five lipped, growing in round clusters on the upper leaf axils. While horehound is edible, it is primarily known as a medicinal plant. The leaves can be eaten raw, sautéed, added as a spice to soups, or dried for tea, but it should be eaten in moderation. Horehound has been used medicinally for centuries to treat coughs but can be toxic if used incorrectly. Further research is suggested before consuming this plant.

INDIAN CUCUMBER, *MEDEOLA VIRGINIANA*

A small perennial herb, Indian cucumber is the only member of its genus. It is found in rich, moist woodlands on slopes and near bogs in the eastern United States. It is often found growing in groups, so if you find one, others may be nearby. When young, the plant is covered with fine hairs. Halfway up the slender stalk, you'll find a whorl of five to ten simple, narrow, elliptical leaves with parallel veins, ending in a point. At the top of the plant is another whorl, this one with three smaller leaves. This double whorl of leaves is a common trait and makes the plant easy to identify, but some younger plants may only have a single whorl. It produces a cluster of small, yellow flowers, with six petals that hang below the top whorl of leaves, and grows small, purple berries. The root is white, edible raw, and tastes of cucumber. It can also be pickled. Indian cucumber is considered a rare plant, so harvesting quantities of it is discouraged.

ITHURIEL'S SPEAR, GRASS NUT, *TRITELEIA LAXA*

A member of the lily family, this perennial herb was named for a character in Milton's *Paradise Lost*. It is native to California and Southern Oregon, grows to two feet tall in dry meadows, grasslands, and sunny woodland areas with sandy soil, at low to mid-elevations. It grows from a corm, at first manifesting grasslike leaves, then an erect, leafless stem topped with a spray of small branches, each ending in a blue to violet flower, all on a disklike inflorescence. The erect, tubular flowers have a six-pointed corolla and six stamens. The whole plant looks vaguely spear-like, especially when it first rises from the soil, with its straight shaft and feathered tip of flowers. The starchy corm is edible; it is sweet and can generally be prepared like potatoes.

JOJOBA, GOATNUT, *SIMMONDSIA CHILENSIS*

Jojoba can be found in the southwestern United States at low and mid-elevations in California, Utah, and Arizona. This evergreen shrub grows up to six feet tall. Its gray-green leaves are about one inch long, ovoid, and grow in pairs that turn upward and move with the sun. Jojoba produces a dark brown seed that looks like an acorn. The seeds are edible raw in extreme moderation, for they contain a wax that causes indigestion. The roasted seeds are more digestible but still should be consumed in moderation. A coffee substitute can be made from the roasted, ground seeds. Jojoba is most commonly known as ingredient in skin and beauty care products and in some places has been cultivated for this commercial application.

JUNIPER, *JUNIPERUS COMMUNIS*, *JUNIPERUS* SPP.

Junipers are coniferous evergreens and a common sight in arid environments from mid- to high elevations across much of the western United States. There are many species of juniper; some are small, sprawling shrubs and others small trees growing to twelve feet. Some have short, pine-like needles that grow in groups of three, and others have short, scaly, cylindrical leaves. All species share as a common trait the distinctive blue or green "berry" with a white waxy surface. These berries are actually fleshy cones. All are more or less edible, with varying degrees of palatability. Junipers rank among the most useful and versatile of plants, whether used for food, medicine, spice, jewelry, crafts, or rituals. Therefore, they were an important plant for many Native American tribes. The berries have a distinctive piney smell and flavor and can be eaten raw or dried and ground to form cakes. They are often used as a spice for wild game. Juniper berries are also used to flavor gin. It is recommended that juniper be eaten in moderation, as it is known to cause kidney and digestive problems in high doses.

KENTUCKY COFFEE TREE,
GYMNOCLADUS DIOICUS

A rare species of deciduous tree found across the Midwest and ebbing into the upper regions of the southern United States, this tree grows to seventy-five feet in height and fifty feet in width. It can be found in a variety of sunny locations with moist, well-drained soils: river valleys, floodplains, hillsides, and woods. Its bark is rough and dark brown and becomes scaly with age. The branches are stout, lacking numerous smaller twigs. The alternate, bipinnately compound leaves are large, growing to thirty-six inches and subdivided into numerous ovate leaflets. The seedpods are reddish brown with a tough, leathery exterior growing to ten inches and encasing several dark brown seeds covered in a gooey gel. The leaves, seedpods, and gel are all toxic, but the seeds are edible when roasted and are most known as a coffee substitute. It is believed the seeds were once a favorite food of woolly mammoths, but without them around to eat and redistribute the seeds, the trees' numbers have declined.

LEMONADE BERRY, SKUNKBUSH, *RHUS TRILOBATA*

This deciduous bush in the *Rhus* genus grows to six feet and is widely distributed along hillsides, plains, and canyons across much of the western United States. The leaves are hairy and three lobed, growing to an inch and a half long on reddish twigs that are hairy when young but become hairless with age. The flowers are small and yellow with five petals. Look for clusters of sticky, hair-covered, red or reddish-orange berries with a single seed. The whole plant smells faintly skunk-like. When ripe, the sour berries can be steeped in water, strained, and mixed with sugar to create a refreshing drink. The berries can also be ground and formed into cakes or dried for later use. Lemonade berry has also been used for a number of medicinal purposes including treatment for bowel and urinary tract problems, toothaches, and stomachaches and as a poultice for skin wounds.

LEMON BALM, *MELISSA OFFICINALUS*

A perennial plant in the mint family with a fragrant, lemony aroma, lemon balm is native to parts of Europe, Asia, Africa, and the Mediterranean. It was a cultivated plant grown in gardens that escaped and became naturalized throughout the United States. It can be found in sunny, temperate areas across the country. It grows to thirty inches tall on square stems (a characteristic of the mint family). The leaves are opposite, heart shaped, with rounded teeth along the margins, and veined, and have fine hairs on the top side. Its small, white flowers grow from whorls at the leaf axils. The leaves are edible. They can be used raw as a flavoring for salads, desserts, and liqueurs, or to add a lemony note to dishes. The dried leaves can be used to make a soothing tea. Medicinally, it has been used to help with sleep disorders, heal cold sores, and alleviate digestive problems.

LICORICE FERN,
POLYPODIUM GLYCYRRHIZA

This small fern grows in cool, moist, shaded locations along the Pacific Coast, ebbing into Idaho and Arizona. It often grows on stumps, downed deciduous trees, dead treetops, or on rocky, mossy outcroppings. Its fronds grow individually, up to two and a half feet tall, from creeping rhizomes. The fronds are pinnately divided into narrow, elliptical, finely toothed leaflets that terminate on a tip. The undersides are dotted with spore casings. The rhizomes contain a very sweet chemical, osladin, making the plant a favorite sugar substitute for many Native American tribes. The fibrous rhizomes can be chewed to extract the sweet, licorice-like flavor or brewed to make tea, infuse liqueurs, or sweeten dishes. The plant was also commonly used to treat colds, coughs, chest pains, shortness of breath, sore gums, vomiting of blood, and sore throats.

LONDON ROCKET, ROCKET MUSTARD, *SISYMBRIUM IRIO*

This is an annual herb in the mustard family native to Europe but now found in the southwestern United States and in the Great Lakes region. Legend has it that the plant was named for its ability to grow quickly postfire, as witnessed after the Great Fire of London in the seventeenth century. It grows to approximately three feet in height on erect, many-branched, slender green stems in yards, fields, deserts, and disturbed sites at low to midelevations and in many places is considered invasive. The shape of the leaves varies greatly. The basal leaves are often lobed and broad, while the upper leaves are linear to oblong, divided with petioles, and grow to six inches. The small, yellow flowers have four petals and four sepals, growing in a cluster on branched tips. Its fruit is a long, slender, green pod with miniscule red seeds. The leaves, flowers, and seeds are edible raw but have an intense spicy, mustard-like flavor. The leaves can be used to create pesto or boiled as a potherb with other greens. The seedpods may be parched and ground into meal. Medicinally, it has been used to treat congestion, reduce swelling, detox the liver, and induce weeping.

MAN-OF-THE-EARTH, WILD POTATO VINE, *IPOMOEA PANDURATA*

This perennial, twining vine in the morning glory family can reach twenty feet or more in length. It is found in the eastern United States in sunny, moist, well-drained soils, growing in fields and thickets and along fences, roadsides, and creek beds. Its flowers are showy and distinctive—wide-open, trumpet shaped, and white with a dark pink or purple throat from which white stamens emerge. The flowers open at dawn and close by day's end. The stems are hairless with alternate, heart-shaped leaves. The tuberous root is edible and tastes of sweet potato. It can grow to gigantic proportions, two feet or more, and weigh over twenty pounds, hence the "man"-of-the-earth. Younger roots are more palatable and less acrid. It is recommended that the roots be boiled in a couple changes of water before roasting to reduce the bitterness. There are a number of similar-looking vines in the morning glory family, so take care when identifying and harvesting this plant.

MANZANITA, ARCTOSTAPHYLOS SPP.

This evergreen shrub, or small tree growing to twenty feet, can be found in dry, sunny places like chaparral shrublands, coastal scrublands, and open forests in the western and southwestern United States. The shrub is identifiable by its red, smooth, twisted branches and fruits that look like little apples turning from green to red as the season progresses. The grayish-green leaves are leathery, oval, and lighter in color on the underside. Its flowers are bell-shaped, white to pink in color, and hang in clusters of up to twenty. There are over one hundred species of manzanitas, with most producing edible fruits and flowers. The ripe berries are sour but can be eaten raw, added to dishes and desserts, or dried and ground for later use. The berries can be crushed and soaked in water to create a cider-like drink. The young flowers are sweet and can be used raw as an addition to salads or as a garnish. Traditionally, manzanita has been used to treat a number of medical conditions: colds, urinary tract infections, stomachaches, bronchitis, and poison ivy.

MARSH MALLOW, *ALTHAEA OFFICINALUS*

Native to North Africa, West Asia, and Europe, this perennial herb has a long history of use as food, medicine, and ornament. Marsh mallow has been widely cultivated and is now found in the wild in the eastern United States. It prefers moist, sunny environments such as bogs, marshes, and the edges of ponds. It grows to four feet tall from a large taproot, sending up multiple erect, branched, hairy stems on which grow alternate, maplelike leaves with three lobes, toothed margins, and dense hairs. Its whitish-pink to pink flowers, with five open petals, are clustered near the top. The whole plant is considered edible. The leaves and flowers can be eaten raw in moderation, cooked as a potherb, or used to thicken soups. The flower buds can be pickled and the roots boiled to create a sweet confection, the original "marshmallow," or sautéed. The seeds can be roasted and ground to make a coffee substitute. Medicinally, it has been used to treat coughs, sore throats, digestive problems, skin infections, and wounds.

MARSH MARIGOLD, WESTERN MARSH MARIGOLD, ELK'S LIP, *CALTHA LEPTOSEPALA*

A perennial herb of the buttercup family common to moist to wet mountain environments such as bogs, alpine meadows, creek sides, edges of ponds, and receding snowbanks in the western United States, western marsh marigold is often one of the first plants to emerge from the snow in alpine environments. Its leaves are glossy, dark green, wavy around the edges, and shaped like broad tongues with larger leaves at the base of the plant and generally form a dome of foliage. It produces numerous leafless flower stalks, rising slightly above the leaves, with one showy white flower per stalk. Common marsh marigold is more widely distributed across the country but has yellow flowers. The flowers have five to ten (but occasionally more) elliptical sepals with a bluish tint on the underside and a disk of yellow pistils in the center. The flower buds can be eaten raw or pickled and the root cooked. Very young leaves can be eaten raw, but it is suggested that older leaves be cooked. The plant should be eaten in moderation due to the presence of the toxin glycoside protoanemonin.

MAYAPPLE, MANDRAKE, *PODOPHYLLUM PELTATUM*

Mayapples are found in moist, deciduous forests, meadows, and shaded roadsides throughout the eastern United States. It often grows in colonies through a network of stems and roots to about two feet tall, with two large, umbrellalike leaves that are deeply parted and toothed and a stalk connecting in the center of each leaf. Below the leaves, where the stem forks, the plant produces a solitary waxy, white flower with six to nine petals. The edible fruit is a single, egg-shaped and -sized berry that turns from green to yellow when ripe. The pulp and skin of the ripened fruit can be eaten fresh, cooked and made into jelly, or squeezed to make a drink. Extreme caution should be used when eating this plant! The seeds, unripe fruit, leaves, stems, and roots are all poisonous, containing the dangerous toxin podophyllin.

MESQUITE, *PROSOPIS* SPP.

Mesquite grows as a shrub or small tree up to twenty-five feet tall in a variety of habitats in lower elevations across the southwestern United States. The trees often have twisted trunks and a dense network of branches. The leaves are fernlike with pairs of pinnately compound leaves. When in bloom, the tree is covered with small, yellow flowers with ten stamens clustered in spikes. The seeds grow in green pods that often twist or curl and grow to ten inches long. Mesquite has been an important food source for many Native American tribes. The flowers can be eaten raw and are used by bees to make a delicious honey. The green seedpods can be ground and eaten raw, boiled in water to make a slightly sweet drink, or fermented. The dried seeds can be ground to make a meal or flour.

MINER'S LETTUCE, *CLAYTONIA PERFOLIATA*

A small, herbaceous, annual plant found in moist, shady, cool environments in the western United States, ranging eastward into the Dakotas, miner's lettuce was a favorite leafy green for miners in the California gold rush of the 1800s, earning its eponymous name. Miner's lettuce grows to one and a half feet tall on narrow stems that attach and converge at the base of the plant. Some of its smaller leaves are spade shaped and grow on long petioles; others are roundish but with subtle tips and perfoliate (with the stems extending through the center of the leaves). Its flowers are small and white or pink and grow in a small cluster near the top of the plant directly above the upper leaves. The whole plant, excluding the root, is considered edible and is high in vitamin C. It can be eaten raw in salads or boiled as a potherb and has a taste similar to spinach.

MOCK STRAWBERRY, INDIAN STRAWBERRY, *POTENTILLA INDICA*

Mock strawberry is an introduced, perennial herb in the rose family that is found throughout much of the continental United States, with the exceptions of the Rocky Mountains, Northern Great Plains, and Northeast. It is a trailing vine that often occurs as ground cover, spreading by stolon and dropping roots as it spreads. It grows in sunny to partly shaded locations with moist, well-drained soil. It resembles wild strawberry, and is often confused for it, but mock strawberry has yellow flowers and wild strawberry flowers are white. Its leaves are trifoliate, veined, and toothed at the margins. It produces small, yellow flowers with five petals and yellow sepals. The fruit resembles that of wild strawberry: red and round with seeds on the outside. The fruit is edible raw or can be used to make jam, contains vitamin C, and is considered flavorless or tasting slightly of watermelon rind. The leaves are edible raw in salads, cooked as potherb, or dried for tea. The crushed leaves can be used as poultice to treat a wide variety of skin problems.

MONKEY FLOWER, MUSK MONKEY FLOWER, *ERYTHRANTHE GUTTATA*

Monkey flower is an herbaceous annual or perennial plant that spreads by rhizomes and can be found growing in moist or aquatic environments, often in or alongside streams throughout the western United States. It grows to three feet tall and has broadly oval, opposite leaves that are toothed at the margins. The flowers grow on a raceme and are yellow and two lipped with a five-lobed calyx and red spots on the lower petals. The flower is said to resemble the face of a monkey. The young stems and leaves are edible raw; with age the leaves become more bitter and are best boiled in a change of water. Traditionally, Native Americans used a poultice of the plant to treat skin wounds and sores, and a tea was used to treat stomachaches, colds, and epilepsy.

NETTLE-LEAF GOOSEFOOT, SOW BANE, *CHENOPODIUM MURALE*

A member of the amaranth family introduced to the United States by Europeans, this annual plant grows on an erect red or red and green stem and reaches heights of two feet. It is widely distributed across the country, preferring light soils, sunny sites, and warm climates. Its leaves are goose-foot-like in shape (hence the name), toothed at the margins, slightly upturned, and powdery on the underside. It flowers with clusters of green inflorescence buds. The nutritious leaves are high in vitamins A and C. They can be eaten raw in salads in moderation, but the plant contains oxalic acid, which can be removed with cooking, making the leaves more palatable as a potherb. The seeds too are edible and can be ground into flour. It is recommended the seeds be soaked in water before processing to remove the toxic saponins.

OXEYE DAISY, *CHRYSANTHEMUM LEUCANTHEMUM*

Oxeye daisy is perennial herb native to Europe and parts of Asia but is now commonly found along roadsides, in fields, and in other moist, disturbed soils across much of North America, especially the northern half at low to mid-elevations. In its first year, this biennial plant grows a robust basal rosette of easily identifiable leaves—look for smooth, dark green, spoon-shaped leaves growing on long stems with rounded, irregular lobes at the margins. During its second year of growth, the plant sends up stalks and produces the characteristic daisylike flowers with a yellow button in the center surrounded by a ring of white, narrow petals, growing two to three inches wide. The young leaves are edible and make a slightly bitter addition to salads. The flowers can be eaten raw or battered and fried. The unopened buds can be used like capers. Medicinally oxeye daisies have been used to treat night sweats, jaundice, digestive problems, coughs, and conjunctivitis.

PALE TOUCH-ME-NOT, YELLOW JEWELWEED, *IMPATIENS PALLIDA*

This annual herb is shrub-like in appearance. It grows to five feet in moist environments—streamsides, marshes, and forest bottomlands in the eastern United States, ranging from Georgia into the Upper Midwest. Its yellow, hanging flowers are unique—inch-long, cone-like, with a small nectar spur hanging from the rear, and three-lobed corollas, the bottom one being larger and showier. Its leaves are simple: alternate with toothed margins, stalked, and often with a powdery coating. The plant is many branched with round succulent stems. It produces translucent seedpods with five valves that hang under the leaves. The pods explode when touched, sending the seeds afar. The small seeds are edible raw and taste of tree nuts. The young leaves and shoots are edible as a potherb. A poultice of jewelweed leaves is a well-known remedy for poison ivy. More research and moderation is recommended before eating this plant, as some sources suggest it contains toxins.

PALO VERDE, *PARKINSONIA MICROPHYLLA*

This small, deciduous tree grows up to twenty-five feet tall. It can be found on washes, hillsides, and flatlands in dry, hot areas at low elevations like the Sonoran and Mojave Deserts of Arizona and Southern California. The tree has smooth, spiny, green bark that is capable of performing photosynthesis. The tree branches are covered with bipinnate, green leaves during the rainy season but often sheds its leaves to conserve moisture during dry seasons. Palo verde produces yellow flowers with five petals and ten stamens in auxiliary clusters. Young, tender seeds and pods can be eaten raw; slightly older seeds may require rehydration before eating. The brown, dried seeds can be rehydrated and used like peas or ground into a flour. The sweet-tasting flowers are edible raw.

PAWPAW, *ASIMINA TRILOBA, ASIMINA SPP.*

The pawpaw is a small deciduous tree growing to forty feet and found across the eastern United States, with a few unique varieties in the Deep South (Florida, in particular). It is the largest native fruit tree in North America and often grows in colonies. It grows in rich, moist, deciduous forests and bottomlands. Its large leaves grow to twelve inches, are alternate, simple, and elliptical, with a narrower, pointed tip. Young leaves are covered with fine, rust-colored hairs, and older leaves become yellow. Its flower is purple to brown, with six petals borne singly at the leaf axils right before the leaves emerge. The fruit is kidney shaped, grows to four inches long, and turns from green to yellowish with dark spots when ripened and contains large, oblong, dark brown seeds. The fruit is edible and custard-like, with a tropical taste reminiscent of mango and banana. It can be eaten raw after removing the seeds or used as an ingredient in desserts and baked goods. Though high in vitamin C, magnesium, manganese, and iron, care should be taken when handling the fruit and leaves, as some people report problems with dermatitis.

PICKERELWEED, *PONTEDERIA CORDATA*

This perennial herb is found along the edges of ponds, lakes, swamps, ditches, and slow-moving streams throughout the eastern United States, excluding southern Florida. It can grow to over five feet in height from submerged rhizomes and rounded tubers. It has smooth triangular stalks. The leaves grow on long petioles, emerging from under the water with multiple stalks. The leaves range in shape from heart-like to long and arrow-like, growing to eight inches. Its distinctive and showy funnel-shaped, two-lipped flowers are violet blue with two yellow spots and fine hairs, growing in dense clusters on a spike that extends beyond the height of the leaves. Young leaves and stalks can be eaten raw or cooked as a potherb. The seeds are edible raw or roasted or can be ground into a flour. The tubers can be eaten raw, candied, boiled, dried for a flour, or roasted and ground as a coffee substitute. As with all aquatic plants, make sure to only consume pickerelweed that grows in clean water sources.

PINEAPPLE WEED, WILD CHAMOMILE, *MATRICARIA MATRICARIOIDES*

A small, hairless annual plant growing to fifteen inches from shallow, weak roots and common to disturbed soils, roadsides, paths, and lawns across much of the United States, pineapple weed gets its name from its pleasant scent. When crushed, the flowers smell identical to pineapple. Often the plant is discovered after one inadvertently steps on it then smells pineapple. The alternate leaves grow to two inches on branched stems and are delicate and deeply dissected. Its yellow flowers are rayless cones, with multiple cones per plant. The flowers can be eaten raw as a trail nibble but are more commonly dried and used to make a chamomile-like tea. The leaves can be eaten raw but are decidedly bitter. Medicinally, it has been used to treat stomachaches, bloating, indigestion, and other digestive problems; menstrual cramps; fever; and colic.

PRICKLY LETTUCE, WILD LETTUCE, *LACTUCA SERRIOLA*

An annual or biennial leafy herb often considered a "weed" introduced from Europe but now widely distributed across the United States, prickly lettuce is found in fields, roadsides, and other sites with disturbed soil. The plant can grow to six feet in height if left to mature. Prickly lettuce is many branched with alternate, oval to oblong, sharply toothed leaves that clasp the spine. Along the midrib of the leaves, you'll find prickly spines that give the plant its name. The flowers are yellow and compound growing in clusters, resembling those of dandelions but smaller, turning to parachute-like achenes. When broken, the plant oozes a white, sticky latex. Young leaves that have yet to develop hard spines are edible but bitter. They can be eaten raw in salads or boiled as a potherb to reduce bitterness. The latex has a mild sedative effect and has been used medicinally and recreationally.

PURSLANE, DUCKWEED, LITTLE HOGWEED, *PORTULACA OLERACEA*

A sprawling, mat-forming annual plant with succulent, fleshy leaves and reddish stems, purslane has leaves that are alternate, about one inch long, shiny, spatula shaped, and widest at the tips. Purslane has small, five-petalled, yellow flowers growing from the tips. The plant has an ancient history of use by humans and is now widespread globally and can be found in every state in the continental United States. It is common to disturbed soils, cultivated lawns, roadsides, and sidewalks. Purslane is a versatile and nutritious source of food, high in vitamins C and E—mucilaginous but with a slightly sour taste. The raw leaves, flowers, and shoots can be added to salads, the stems and leaves boiled as a potherb, the stems pickled, and the small seeds dried and ground as flour. Traditionally it was used to treat earaches, diarrhea, stomachaches, and worms and was used as a poultice for burns.

RASPBERRY, RED RASPBERRY, *RUBUS STRIGOSUS*

Raspberries are part of a large family of brambles. They grow in thickets on slopes in sunny areas across the United States. The plant grows to six feet on woody, arching stems covered with sharp bristles. The green leaves commonly come in three leaf divisions (but sometimes five) and are toothed and grayish on the underside. It produces a white flower with five petals and then green fruit that ripens to red. The fruit forms hollow shells and is easily plucked from the stems when ripe. Raspberries are a tart and delicious wild edible. They can be eaten raw, baked in desserts, used to create jam, or dried for later use. Young, tender shoots can be peeled and eaten raw or cooked. The dried leaves can be used to make tea—though caution should be used to make sure the leaves are thoroughly dried and not just wilted, as they can produce a mild toxin.

SALMONBERRY, *RUBUS SPECTABILIS*

A member of the rose family that grows to twelve feet in height from spreading rhizomes and forms dense brambles, salmonberry can be found in cool, moist, partly shady locations along the Pacific Coast from Northern California northward, with a small population in Idaho, frequently found alongside streams and roadsides and in open woodlands. Its name is thought to come from the Native American tribes who enjoyed pairing the berries with salmon. Its arching stems are shedding, golden brown, with the younger ones often having some thorns near the base. The toothed leaves are subdivided into three leaflets. The pink to magenta flowers have five petals. The sweet, edible berries are yellow, orange, or red and can be eaten raw or prepared like raspberries: used for jams, dessert fillings, or wine. The young sprouts can be peeled and eaten raw or boiled. Salmonberry has been used to treat medical conditions such as stomachaches, skin problems, toothaches, diarrhea, dysentery, and labor pain.

SASSAFRAS, *SASSAFRAS ALBIDUM*

This medium-sized tree in the laurel family can be found at the edges of forests and woodlands and in meadows and bottomlands throughout the eastern United States. Sassafras produces three types of leaves: toothless, ovate leaves with one, two, or three lobes. The two-lobed leaves resemble a mitten. It has deeply furrowed, reddish-brown bark and green, many-branched twigs. The tree produces clusters of small, yellow flowers, and the fruit is small, dark blue, egg shaped, and connected to the stem with a red cup. The roots can be boiled to make an aromatic tea or dried and ground as a spice. The dried leaves can be added to soups as a thickening agent. Care and more research is recommended before consuming sassafras, as studies have shown it contains carcinogens. During colonial times sassafras became highly sought after in Europe and was traded in large quantities.

SEA BEANS, GLASSWORT, PICKLEWEED, *SALICORNIA MARITIMA*

Sea beans are herbaceous annuals and halophytes, meaning they only grow in saltwater environments. They can be found primarily around the perimeter of the United States in coastal marshes and bays but also inland in places with saltwater lakes, springs, or other high-alkaline water sources. It often grows erect to twelve inches in dense colonies. It produces sprawling succulent, leafless stalks with branched, jointed scales off a woodier, thick stem. Its flowers grow in cylindrical spikes in groups of up to seven at the joints. Its Latin name means "salt horn," an apt description of the plant's form and taste. The stalks are edible and best when young, or just the tips can be harvested later in the season. Sea beans are high in protein and vitamin A, iron, and calcium. They are salty and crunchy when eaten raw and can be added to salads. They can also be blanched as a side dish or pickled. They have been processed to make sodium carbonate and used in the production of glass.

SEGO LILY, MARIPOSA LILY, *CALOCHORTUS NUTTALLII*

A slender perennial herb growing to eighteen inches in height, these lilies are found in woodlands, grasslands, sagebrush scrub, and on dry foothills along the Rocky Mountain corridor and into Utah and Nevada. Other similar species of mariposa lilies can be found throughout the western United States and are identical in edibility. Sego lily bulbs grow relatively deeply and are onion-like in appearance. Its leaves are few and grasslike, mostly basal, and clasp the thin stalk. The flowers are white to pale yellow with three petals and three sepals with hints of light purple or magenta with a yellow base, cuplike in shape but open, up to three inches across, with one to four flowers per plant. Mariposa lilies were an important food source for many Native American tribes in the west. The flower petals can be eaten raw as a sweet trail nibble. The nutritious bulbs can be eaten raw but are more commonly roasted, steamed, or dried and ground for flour that can be added to breads or as a thickening agent in soups. Medicinally, it has been used to treat acne and aid in childbirth. These lilies are rare enough that harvesting should be done very conservatively to maintain healthy populations of this beautiful flower.

SHEEP SORREL, FIELD SORREL, *RUMEX ACETOSELLA*

A perennial member of the buckwheat family native to Europe and Asia, this plant is now widely distributed and common throughout North America. It can be found growing in sunny, sandy, disturbed soils, fields, grasslands, abandoned mines, and blueberry patches. It spreads quickly, forming patches from rhizomes, sending up reddish, erect stems that branch near the top, growing to eighteen inches in height. The alternate leaves are hastate, or arrow-like, in appearance and predominantly basal. Near the base of the plant, they grow on petioles and are triangular tipped and two lobed. The upper leaves become stemless and are without lobes. The flowers are small and maroon on female plants, yellow green on males, growing on racemes. Like other sorrels, this one contains oxalic acid, giving the plant a tart, lemony flavor but also requiring it to be consumed in moderation. The leaves can be eaten raw in salads and used to curdle milk and flavor or thicken soups. The seeds are also considered edible.

SHISHO, BEEFSTEAK PLANT, WILD BASIL, *PERILLA FRUTESCENS*

An annual herb originally from India, shisho is now naturalized and considered invasive, found throughout much of the eastern United States, excluding the Northeast. It grows on erect, square, purple stems with vertical grooves, up to three feet and is found in pastures and gardens and along roadsides and streams. Shisho is considered toxic to livestock. Its leaves are opposite, crinkly, and egg shaped with sharp tips and come in either green or purple with sawlike, serrated edges and some hairs on the underside. It has pink flowers with four stamens growing from spikes near the top of the plant. The leaves are spicy, warming, and aromatic—like basil mixed with cinnamon. They can be eaten raw, fried, or used as a spice in dishes, for pickling brine, or for tea. An oil high in omega-3 can be extracted from the seeds and used for cooking or as a flavoring. The young sprouts can be used as a potherb. It has also been used as an insecticide and to treat colds, coughs, nausea, and constipation.

SHOOTING STAR, HENDERSON'S SHOOTING STAR, *DODECATHEON HENDERSONII*, *DODECATHEON SPP.*

Henderson's shooting star is found west of the Cascade Mountains in open forests and meadows, but other species of shooting stars may be found across the western United States from sea level to alpine environments. This member of the primrose family is often one of the first to appear in spring. The plant is small, usually less than one foot in height, but easily spotted and identified by its unique nodding purple or dark pink flower. The flower petals bend back, giving the appearance of a "shooting star" and exposing a band of yellow at the base and a black basal zone. It arises from a fibrous root and has round to oval leaves on long petioles near the base of the plant, growing to three inches long. The flowers and leaves can be eaten raw in salads and the roots roasted or boiled.

SILVERWEED, SILVERWEED CINQUEFOIL, *POTENTILLA ANSERINA*, *ARGENTINA ANSERINA*

This perennial herb is found throughout cooler regions of the United States: the West Coast, Upper Great Plains, Upper Midwest, and Northeast. It prefers moist, open environments like mountains, plains, and meadows. It grows from a root network and puts down stolons as it spreads, so it often forms large colonies. The leaves have a distinctive silver-green tint and are hairy, growing to eight inches in length, pinnately divided into up to twenty-five toothed, elliptical leaflets that are folded slightly upward. The yellow flowers have five petals, five sepals, and five small bractlets. The edible roots are long and thin and have a taste reminiscent of sweet potatoes or parsnips. They can be eaten raw and taste nutty but are slightly bitter. More often they are boiled, fried, or sautéed as a starchy root vegetable. They can also be dried and stored for later use. Medicinally, this plant has been used to treat dysentery, diarrhea, toothaches, indigestion, and skin problems.

SKUNK CABBAGE, WESTERN SKUNK CABBAGE, SWAMP LANTERN, *LYSICHITON AMERICANUM*

A large perennial native herb in the arum family, this cabbage grows in swamps, in bogs, near streams, and in wet woodland areas at low elevations in the western United States from California to Washington and over to Montana. As you can deduce from its name, the plant is quite malodorous. It grows to four feet from a fleshy, bulblike rhizome with many rootlets. The base of the central stem is surrounded by large, glossy, oblong leaves. A showy, yellow spathe clasps the stem and surrounds the spadix covered with numerous small, yellow-green flowers with four to six sepals. The starchy roots are edible after being roasted and can be dried then ground to flour. The young shoots and leaves are edible as a potherb after being boiled in several changes of water, and the large leaves have been used to wrap foods for roasting. The plant contains calcium oxalate, which causes burning and choking sensations, but can be removed with sufficient cooking.

SOAP PLANT, WAVY-LEAFED SOAP PLANT, *CHLOROGALUM POMERIDIANUM*

This perennial plant in the agave family has many uses. It is found in a limited range, just in parts of California and Oregon. It grows from the coasts up to the foothills at midelevations in dry, sunny environments and prefers chaparral scrublands, rocky hillsides, open forests, and grasslands. It grows from a large, brown fibrous bulb that resembles an elongated coconut. Its leaves are long, linear, narrow, and wavy, growing to two feet in length and radiating around the base of the plant (resembling the leaves of lilies). The plant sends up a long stalk, growing to six feet in height. The white flowers grow on a branched inflorescence and are six petalled and starlike, with a green or purple midvein. They open in the evening and die during the next day. As the names suggest, the bulb can be used as a soap or shampoo. The saponins in the bulb can be used to stupefy fish and the fibrous husks used to make brushes. The young leaves are edible raw or as a sweet potherb. The bulbs are edible but must be slow roasted for a long time to remove the soapiness. This plant has a long history of being an important source of food, medicine, and tools for many Native American tribes.

SOLOMON'S SEAL, *POLYGONATUM* SPP.

Solomon's seal grows across much of the eastern United States in forests, woodlands, and thickets with dappled light. It grows to approximately two feet long with a single arched stem. The leaves alternate along the stem and have parallel veins. The plant produces unique bell-shaped, white to greenish-yellow flowers that dangle beneath the length of the stem—turning to dark bluish-black berries later in the season. The berries are poisonous and should not be ingested! The rootstock is whitish in color when cleaned and bears the "seals" that give the plant its name. Look for round marks with two triangular shapes—these scars form from previous stem lengths that have died back and resemble King Solomon's seal. The young shoots can be eaten raw or boiled—prepared in ways similar to asparagus. The rootstocks are high in starch and can be eaten once boiled. They have also been dried, ground, and used as a flour during times of famine.

SPICEBUSH, LINDERA BENZOIN

A deciduous, medium-size shrub in the laurel family, spicebush grows to over twelve feet in the understory of forests and along streams in moist, partly sunny environments across much of the eastern United States, ranging west into Texas. Its bark is grayish brown and has small, white lenticels. You'll often find spicebush growing in colonies. The leaves are light green, alternate, simple, and ovoid, with narrow tips at each end and are at their widest just past halfway up the midrib, turning yellow in the fall. When crushed, the leaves give off a distinctive aroma—smelling of citrus and allspice. The flowers are small and yellow with six sepals and grow in clusters. The female shrubs produce copious clusters of red ellipsoidal drupes that are about one-half inch long and contain a single seed. The drupes too are very aromatic. The berries, bark, leaves, and twigs can all be used as spice, flavoring, or to make tea. It is often used as a substitute for recipes that call for allspice.

SPRING BEAUTY, WESTERN SPRING BEAUTY, *CLAYTONIA* SPP.

This small, perennial plant grows to eight inches in height and is often among the first to bloom in moist, montane environments such as meadows, valleys, and slopes in the western United States. This beautiful, delicate plant is easy to identify based upon its unique flower. Its flowers are white or pink with reddish veins and have five petals, five stamens, and two sepals. Western spring beauty grows from a small corm. Its hairless stem is reddish at the base and, early in the season, sports two long, lanceolate, opposite basal leaves. Later in the season, these leaves die back, and two smaller leaves higher up the stem remain. The flowers and leaves are edible raw as additions to salads. The crisp corm can be eaten raw or cooked and prepared in a manner similar to potatoes.

STONECROP, *SEDUM* SPP.

Stonecrop is a succulent perennial plant that includes a wide number of species that can be found across the United States. As the name suggests, it prefers rocky soil conditions and is commonly found in meadows, on rocky hillsides, and in other dry, sunny environments. Stonecrop normally stays close to the ground, forming spreading mats of leaves and rhizomes. Some species have round, flat leaves while others are cylindrical. The leaves and stems are high in vitamins A and C and can be eaten raw, used as an addition to salads, or boiled as a potherb. Younger plants are considered more palatable. Medicinally, a poultice of leaves has also been used to treat minor skin irritations and as a tea used to treat eye, lung, and throat ailments.

SUMAC, STAGHORN SUMAC, *RHUS TYPHINA*

Staghorn sumac is a small, deciduous tree that grows to thirty feet tall and forms colonies throughout the eastern half of the United States, often found in poor, open, dry disturbed soils: old fields, fencerows, savannahs, and roadsides. Its branches are forked and covered in velvet hair reminiscent of a stag's antlers. Its alternate leaves are pinnately compound and grow to twenty inches long, with upward of thirty leaflets that turn red in the fall. Its small, yellow-green flowers grow in pyramid-shaped terminal panicles, turning to reddish drupes. Another species, smooth sumac, or *Rhus glabra*, is a very common type of sumac that's found across the continental United States. The red drupes can be soaked in water and strained to create a lemonade-like drink or dried and ground and used as a spice. There are over two hundred and fifty species of sumac. The red-berried ones are all edible and can be used like the one pictured. The notorious poison sumac has white berries.

SUNFLOWER, *HELIANTHUS ANNUUS*

Sunflower is a common sight along roadsides, in fields, and on foothills across much of the United States. It is a native, annual, herbaceous plant that grows to nine feet in height with branched, coarsely hairy stems. The alternate leaves are three veined, often heart shaped, and toothed, growing to eight inches. The well known and easily identified showy flower heads grow to five inches wide and range in color from yellow to orange or red with brownish central disks that fruit and form seeds. This important plant has a long history of use and cultivation by many Native American tribes. The calorie-rich seeds are a versatile food. They can be eaten raw or roasted, combined with other ingredients to form cakes, or boiled to release an oil for cooking. The shells can be roasted to make a coffee substitute. Sunflowers have been used to treat a plethora of medicinal conditions including snakebites, lung ailments, bladder problems, fever, and rheumatism.

SWAMP HEDGE NETTLE, WOUNDWORT, BETONY, *STACHYS PALUSTRIS*

Swamp hedge nettle is a perennial plant found growing in moist meadows, bogs, and foothills across much of the western United States. This member of the mint family has a hairy, erect, four-sided stem and grows to three feet in height. Its leaves are oblong to lanceolate and toothed, up to three inches long. It has hooded pink, pale purple, or white flowers with a three-lobed lower lip and dark veins or spots and grow in whorls on terminal spikes. In the fall, the plant produces edible tubers that can be eaten raw, roasted, or pickled. The dried roots can be ground into a flour. The flowers and seeds are also edible. A poultice of the leaves has been used to treat wounds and sores and to reduce pain and swelling. Additionally, a medicinal tea has been ingested to treat sore throats, headaches, bladder problems, and hangovers.

WALNUT, ARIZONA WALNUT, *JUGLANS MAJOR*

Juglans major is a type of walnut found primarily in Arizona, Utah, New Mexico, and Texas, growing in canyons and along riparian corridors. Black walnut (*Juglans nigra*) is found in the eastern United States and also prefers moist soils: bottomlands, floodplains, and waterways in deciduous forests. Both species are similar in appearance and edibility. Walnut trees can grow to be quite tall, up to fifty feet, and have an open, rounded profile. The leaves are pinnately compound, fernlike, with up to thirteen leaflets that are lance shaped and finely toothed. The bark is furrowed on the trunk, and the flowers grow in long, green clusters. The four-lobed nuts are surrounded by a thick, green husk. The husks and leaves have a distinctively pungent odor. The brain-shaped nut meat, though small, is delicious and can be eaten raw or roasted, ground to make nut butter, or boiled to extract the oils.

WAPATO, DUCK POTATO, ARROWHEAD, *SAGITTARIA LANCIFOLIA*

Wapato can be found growing in colonies in the shallow waters of lakes, ponds, and wetlands throughout most of the United States (desert areas excluded). This species, *Sagittaria lancifolia* is found in the southeastern region of the country. The leaves and flowers emerge from a rhizome at the bottom of the water source and are found above the surface, growing to heights of three feet or more. The plant has large, arrow-shaped green leaves with parallel veins meeting at the middle and growing in a rosette. The flowers are white with three round petals. The edible corms, or "potatoes," can be found dispersed around the base of the plant in the mud at various depths. They float to the surface when dislodged. The carbohydrate-rich corms can be prepared like potatoes, boiled, roasted, dried and ground into a flour for cakes, or used as a thickening agent for stews. The young leaves and stalks can be boiled and the flower petals eaten raw. Wapato was an important source of food for many Native Americans.

WATERCRESS, *NASTURTIUM OFFICINALE*

Watercress is widely distributed across the United States. It is an aquatic or semiaquatic plant growing in or along slow-moving streams and springs. It often forms masses of floating colonies, with some of the roots visible above the soil. It produces small, white flowers with individual petals of about one-eighth of an inch growing in terminal racemes. Its smooth, wavy leaves are pinnately divided with up to eleven leaflets. Watercress has been enjoyed by humans across the globe for centuries and can be found in many high-end markets today. The leaves are edible raw and make a peppery addition to salads. They can also be steamed or boiled as a potherb and dried and used as an herb or to brew tea.

WATER LILY, WHITE WATER LILY, *NYMPHAEA ODORATA*

Water lilies can be found perennially in shallow still or slow-moving bodies of water across most of the continental United States. It can grow to over six feet, depending upon the depth of the water. It grows from a large root and system of rhizomes with long, round petioles attached to large, round, leathery leaves floating on the surface, green on top and purple on the underside. There is a triangular notch from the petiole at the center of the leaf to the outer edge. The large, white, fragrant, floating flowers have a concentric series of narrowly elliptical leaves with numerous yellow stamens. It opens during the day and closes at night. The whole plant is considered edible. The flowers can be eaten raw, boiled, or pickled while buds. Young leaves can be eaten raw, older ones cooked as a potherb. The rhizomes can be eaten raw, boiled, or roasted and the seeds eaten raw or cooked. Medicinally, it has been used to treat toothaches, colds, sore throats, and diarrhea.

WILD GINGER, WESTERN WILD GINGER, LONG-TAILED WILD GINGER, *ASARUM CAUDATUM*

An evergreen herb found growing in the shaded understory of conifer forests, on hillsides, and in montane environments of the western United States (excluding the desert southwest), this ginger often grows in large colonies from a network of rhizomes. Another species of wild ginger, *Asarum canadense*, is common to the eastern half of the country. Although similar in taste to commercial ginger, it bears no relation. This matted plant stays close to the ground and has two glossy, heart-shaped leaves that grow to four inches wide. It produces a single, hairy, bell-shaped, brown flower with three long-tailed sepals. The flower often rests on the ground, enticing ants to enter and disperse the seeds. The roots can be used in similar ways to commercial ginger, raw or dried and ground as a spice. They can also be candied or pickled. The leaves can be used to make tea. Medicinally, wild ginger has been used to treat minor cuts, coughs, stomachaches, fever, and earaches, among other treatments. Care and further research is recommended before using the plant, as it may induce nausea and cause skin irritations and is known to contain aristolochic acid, a carcinogen.

WILD OATS, *AVENA FATUA*

This annual grass is distributed across the United States but is especially prevalent in the west. Wild oats can be found growing near fields, disturbed soils, and along streams and roadsides. It resembles the oat commonly used as a breakfast food (*Avena sativa*). It grows to about four feet tall and has a thin, hollow stem and twisted awns at its base that support long, broad leaves. Its florets are surrounded by veined, papery bracts with dropping elliptical spikelets. The grain is edible, but the hairs and bracts must be removed first by a process of chaffing and winnowing. Afterward, the grains can be ground and used as flour. Wild oats are mildly sedative and can be used medicinally to aid in stress reduction and insomnia or help with drug and smoking addictions.

WILD OREGANO, PONY BEEBALM, *MONARDA PECTINATE*

This native, annual herb is a member of the mint family. It grows to three feet tall and is found throughout the Great Plains and southwestern United States from Missouri to California in sandy washes and canyons and on rocky hillsides. Its stems are brownish purple with numerous leaves that are opposite, lanceolate to oblong, growing to an inch and half long, and commonly, but not always, toothed and (rarely) finely haired. Its tubular flowers are white to light pink, with a curved upper lip, a three-lobed lower lip, and two stamens growing on an inflorescence of spherical clusters. The leaves are edible and give off a strong odor similar to mint mixed with oregano. They can be used as an herb to flavor dishes or dried to make tea. The leaves contain the antiseptic thymol and can be used to treat a wide variety of wounds, abrasions, and other skin conditions. Historically, it has also been used to treat stomachs, lung conditions, oral infection, and fever.

WILD RADISH, JOINTED CHARLOCK, *RAPHANUS RAPHANISTRUM*

An introduced annual or perennial herb in the mustard family, originally cultivated in Asia, Europe, and North Africa and related to commercial radishes, the wild radish can now be found throughout most of the continental United States in places with well-drained, sandy soils: disturbed grounds like pastures, lawns, and roadsides. It grows to two and half feet tall from a large taproot. The larger basal leaves are spatula shaped or oblong-elliptic with a large, round, lobed top and smaller lobed leaves toward the base. Further up the stems, the leaves are smaller and less lobed. The white to pale yellow flowers grow in clusters on branched stems, with four paddle-shaped petals with dark veins. The seedpods are smooth and green with division between seeds, growing to one and a half inches long. Young leaves can be eaten raw in salads or boiled as a potherb and are spicy and mustard-like in flavor. The seeds can be ground to make a mustard-like condiment. Young seedpods can be eaten raw. The flowers are edible raw, and the flower buds can be steamed.

WILD RHUBARB, CANAIGRE, DESERT DOCK, *RUMEX HYMENOSEPALUS*

Wild rhubarb can be found growing in dry, sandy desert washes in moist to arid sunny locations throughout the southwestern United States. This perennial grows dense clusters of large (up to two and half feet) alternate, lance-shaped, wavy leaves from a substantial tuber-like root that contains an abundance of tannins. Its greenish flowers grow in whorled clusters on a terminal panicle and turn reddish brown with age. The leaves are edible but contain oxalic acid, giving the plant a sour taste but also slight toxicity. Boiling the leaves in several changes of water removes the oxalic acid and is recommended. The plant has a myriad of medicinal uses and was an important plant for many Native American tribes. It was used to treat wounds, diarrhea, sore throats, coughs, sunburns, and colds.

WILD ROSE, SWEETBRIER ROSE, *ROSA EGLANTERIA*, *ROSA SPP.*

There are over forty species of roses, both native and introduced, found in the United States, all of which are edible with varying degrees of palatability. Sweetbrier rose (pictured) was introduced but now is widely distributed and common to fallow fields, roadsides, forests, and fencerows. This shrub grows to ten feet on arching, thorny stems with alternate, pinnate, compound leaves doubly toothed along the margins, further subdivided into leaflets. The flowers are pink and showy, with five petals and numerous pistils. Roses produce a small, red or reddish-orange, round, vase-shaped fruit called a "hip." These hips are high in vitamin C and are the most commonly eaten part of the plant. They can be eaten raw as a trail nibble or survival food, used to make jams, or dried and powdered to make a drink or tea. The flower petals can be eaten raw as an addition to salads. The leaves may be dried for tea. Young, peeled shoots are also edible.

WINTERGREEN, EASTERN TEABERRY, *GAULTHERIA PROCUMBENS*

This small, low-growing evergreen perennial can be found in coniferous and deciduous forests of the eastern United States from Minnesota to Alabama and back up to Maine. The plant forms colonies from a network of horizontally growing roots and sends up slight stems that rise just a few inches off the ground. Each stem holds several ovate to elliptical, dark green leaves that have a waxy appearance on the top side and grow to two inches long. The small, lantern-like, white or pink flowers droop from anthers attached to the top leaf axil. The flower's corolla has a five-toothed tip. Plants that grow in fertile conditions produce small, red, apple-like berries called "teaberries." The berries are edible raw as a trail nibble and are used as a flavoring for teas, candy, and gum. The leaves can be used to make tea, flavoring, or an essential oil.

WOLFBERRY, DESERT THORN, *LYCIUM PALLIDUM*

Look for wolfberry growing in arid environments across the southwestern United States from the Sonoran Desert to dry plains and the foothills of the Rocky Mountains. This shrub grows to about six feet in height and has numerous branches with intermittent thorns and small, ovate leaves that often grow in bunches and are covered with a white film. Its tubular flowers are white with purple veins. When in season, wolfberry is covered with edible fruit. These small red or orange berries are oval and have a flavor that is savory and slightly sweet, like tomato with a hint of citrus. They should be eaten raw in limited quantities; as with many members of the nightshade family, moderation is recommended. The berries can be cooked down, added to soups, boiled in water to make syrup, baked to make fruit leather, or dried for later use.

WOOD NETTLE, *LAPORTEA CANADENSIS*

This plant is found in the eastern United States in deciduous forests and other rich, moist environments like streamsides, floodplains, and seepages. It grows to three feet tall from a tuberous root with opposite and alternate teardrop-shaped leaves, pinnately veined with serrated margins. The leaves grow near the top half of the plant and are covered with stinging hairs that are to be avoided! It produces green flowers—the males on cymes springing from leaf axils and the females on branched, erect cymes that grow from the top of the plant. It is related to another common edible nettle, stinging nettle. Stinging nettle is differentiated by its narrow, opposite leaves. Young nettle leaves are a coveted wild food and can be cooked and served in a manner similar to that of spinach; luckily cooking removes the stinging hairs. This plant has also been used as a diuretic, fever reducer, and aid in childbirth.

YAMPA, YAMPAH, GAIRDNER'S YAMPAH, *PERIDERIDIA GAIRDNERI*

Yampah grows in moist, montane environments in the western United States; meadows, plains, and hillsides are good places to search. The slight plant grows one to three feet in height and is topped by a flat, roundish umbel that is subdivided into umbellets of tiny white flowers. Its slender leaves are mostly basal, and once pinnately divided, with enlarged petioles. The whole plant, when crushed, smells of caraway. The edible corm looks like a nutlet. It is high in carbohydrates and quite good. It can be eaten raw, roasted, steamed, dried for later use, and ground into meal. Yampah was an important and highly relished food for many Native American tribes.

YELLOW BELLS, YELLOW FRITILLARIA, *FRITILLARIA PUDICA*

Yellow bells grow in sagebrush, prairie, and woodland environments in the western United States. It is a small plant, usually growing less than one foot in height from a shallow, disklike white bulb surrounded by small bulblets and fine, short roots. Its single stem changes from white to red to green and produces up to eight long, elliptical, needlelike leaves. Its nodding flowers are yellow and bell shaped, with up to three per plant. The yellow flowers are early to bloom, often a harbinger of spring. Later in the season, it produces green, cylindrical, three-chambered seedpods. The bulbs are high in starch, protein, iron, and other nutrients and were a staple crop for many Native American tribes. The bulbs can be eaten raw, boiled, or dried and stored for use later in the season.

YELLOW WOOD SORREL, *OXALIS STRICTA*

An herbaceous plant that can be either perennial or annual, yellow wood sorrel is found across almost all of the continental United States, excluding a few states in the west. It grows in forests, fields, and lawns with full sun or partial shade and moist, well-drained soil. Growing to approximately fifteen inches in height when erect, it often becomes prone and sprawls when it ages. The alternate leaves resemble those of a clover, each leaf subdivided into three heart-shaped leaflets that crease and bend upward along the midrib. At night the leaves close and then they reopen during the day. Its flowers are small and yellow with five petals and ten stamens. It produces cone-shaped seedpods that stand erect at the tops of the plant. The leaves, flowers, stems, and seedpods are all considered edible and contain oxalic acid, giving the plant a refreshing sour flavor. The presence of oxalic acid also means the plant should be eaten in moderation, as it inhibits the absorption of calcium. The plant can be eaten raw, added to salads, used for flavoring, juiced to produce "vinegar," or used to make tea and other beverages.

YERBA SANTA, NARROWLEAF YERBA SANTA, *ERIODICTYON ANGUSTIFOLIUM*

Yerba santa is a native, perennial, spreading shrub that grows to six feet in height, found in pinyon-juniper woodlands and desert regions of the southwestern United States. Its name translates from Spanish to "holy herb," indicative of its many medicinal powers. Its leathery leaves are dark, glossy, and green, elliptical to lanceolate, narrowly linear, toothed, and grow to four inches. The leaves are resinous and sticky on the top side and woolly on the underside. Its small flowers grow on terminal panicles, are white to lilac, trumpet-like in shape, with five-lobed petals. The fruits are ovoid capsules with four chambers. The fragrant leaves can be used to brew tea. Among its many medicinal applications, yerba santa has been used to treat stomachaches, colds, respiratory conditions, poison oak, skin irritations, and rheumatism and used as a laxative.

JIMMY W. FIKE was born in Birmingham, Alabama, in 1970. Even at an early age, he showed a penchant for art and love for exploring nature. He earned a BA in art from Auburn University and an MFA in photography from the Cranbrook Academy of Art. Fike's photographs have been exhibited extensively across the United States, published in the *Washington Post*, *Boston Globe*, *Los Angeles Times*, and *Mother Jones*, and can be found in the permanent collections of the George Eastman Museum, St. Lawrence University, and the University of Alabama Birmingham. He currently lives in Phoenix, Arizona, with his daughter, Isobel, and dogs, Sallie and Scrappy, and works as residential art faculty at Estrella Mountain Community College. www.jimmyfike.com